The Heart of Light

The Heart of Light: A Holistic Primer for a Life and Career in Lighting Design and Production is a fresh look into the ever-evolving fields of lighting design and technology for arts and entertainment.

Full of practical information, historic perspectives, engaging projects, and opportunities for deep inquiry, practice, and reflection, this book offers a well-rounded foundation in the art, technology, and industries of light. It explores a wide range of topics, including:

- how to observe, communicate about, and use light effectively
- how quietive practices can deepen the creative process
- current lighting equipment used across the various arts and entertainment industries and strategies for keeping up with its rapid innovation
- how to choose a career path that keeps you inspired, as well as ways to search for work with dos and don'ts of effective career building
- how to cope with and celebrate the unknown and related challenges of implementing a design under pressure
- considerations for using self-reflection to be successful and impact positive change.

From her perspective of lighting designer, educator, and contemplative practitioner, the author explores lighting not just as a subject, but as an invitation to a fulfilling lifelong adventure.

Written for students of Theatrical Lighting courses and emerging lighting professionals, *The Heart of Light* is a must-read for anyone intrigued by the power of light.

Deanna Fitzgerald is a professional Lighting Designer and member of United Scenic Artists. Her lighting design credits include a wide range of theatre, dance, opera, circus-themed shows, puppets, architectural lighting, and more. She toured as the Lighting Director for the international tour of *STOMP* for six years and designed its Las Vegas incarnation *STOMP OUT LOUD*. At the University of Arizona she is an Associate Dean for the College of Fine Arts and a Professor in the School of Theatre, Film, and Television where she directed the BFA and MFA lighting design and technology areas for 12 years. Deanna serves on the Boards of Directors for URTA (University Resident Theatre Association), USITT (United States Institute of Theatre Technology), and the Western Region Exam Committee of United Scenic Artist Local 829. She is a yoga and meditation teacher and conducts classes and workshops focused on using these and other quietive practices to aid in the creative process.

The Heart of Light

A Holistic Primer for a Life and Career in Lighting Design and Production

Deanna Fitzgerald

Map and icon graphics by Mandy Wagner

Routledge
Taylor & Francis Group

NEW YORK AND LONDON

Cover image: Courtesy of University of Arizona School of Dance and Benny Fung, choreographer; photo by Deanna Fitzgerald

First published 2022
by Routledge
605 Third Avenue, New York, NY 10158

and by Routledge
4 Park Square, Milton Park, Abingdon, Oxon, OX14 4RN

Routledge is an imprint of the Taylor & Francis Group, an informa business

© 2022 Taylor & Francis

Map and icon graphics © 2022 Mandy Wagner

Library of Congress Cataloging-in-Publication Data
Names: Fitzgerald, Deanna (Lighting designer), author. | Wagner, Mandy, illustrator.
Title: The heart of light : a holistic primer for a life and career in lighting design and production / Deanna Fitzgerald ; map and icon graphics by Mandy Wagner.
Description: New York : Routledge, 2022. | Includes bibliographical references and index.
Identifiers: LCCN 2021034231 (print) | LCCN 2021034232 (ebook) | ISBN 9780367901172 (hardback) | ISBN 9780367901196 (paperback) | ISBN 9781003022725 (ebook)
Subjects: LCSH: Stage lighting—Vocational guidance.
Classification: LCC PN2091.E4 F58 2022 (print) | LCC PN2091.E4 (ebook) | DDC 792.02/5—dc23
LC record available at https://lccn.loc.gov/2021034231
LC ebook record available at https://lccn.loc.gov/2021034232

ISBN: 978-0-367-90117-2 (hbk)
ISBN: 978-0-367-90119-6 (pbk)
ISBN: 978-1-003-02272-5 (ebk)

DOI: 10.4324/9781003022725

Typeset in Sabon
by Apex CoVantage, LLC

Contents

CHAPTER 1

Introduction and an Invitation

One of the exciting things about lighting design is that it requires both artistic and technical skills, not to mention management, leadership, organization, patience, and a good sense of humor. Not only must you harness the elements of design and create effective compositions in the way that other visual artists do, but you must do those things by using technology and skills that in some ways feel unrelated to the product they produce.

Think about a painter who picks up a brush, dips it in the paint, and applies that paint to canvas to create their work. Painting requires planning and technique, but consider the unique gap between the tools a lighting designer uses in order to get to a product and the product itself. The effective picture that the lighting designer creates requires schematic drawings, lights that have to be plugged into cables connected to mechanical rooms, and hours of computer programming in a syntax that doesn't sound anything like a visual image. This is part of the reason that *lighting programmer* and *entertainment technician* are their own careers separate from lighting designer, but imagine a painter trying to create a painting by telling someone else with a brush in their hand what to do. You might argue that scenic designers have to be able to instruct scene painters in that way, but even in that case there is still usually a hand connected to a brush, connected to the paint, connected to the canvas. For the lighting artist there are usually more pieces of technology and more space between the artist, their medium, and the observer, who – by the way – may not even realize that medium (light) is there.

My approach to lighting design and the education of designers is informed by years of another vital set of practices, which we'll call

DOI: 10.4324/9781003022725-1

quietive practices. If you think about the kinds of over-arching skills a lighting designer or collaborative artist need – an awareness of what is around them, an ability to maintain focus on objectives as ideas evolve, an openness to others' perspectives, an ability to keep generating fresh ideas and hold a lot of information in their head at one time, stay calm under pressure, etc. – all of these things can be a routine outcome of many of the quietive or *contemplative* practices available. If you've tried any of these things and think it's not for you, I invite you to keep an open mind and read on, because there are lots of examples of pros who thought the same thing but just hadn't found what they needed yet.

Consider this: in order to create a good design, we have to be able to generate new ideas. In the 1990s, popular psychology told us that our minds come up with an awful lot of thoughts throughout the day, but most of them are the same thoughts. Truly new ideas come when our minds stop looping through all the information we already know. If quietive practices can help us do that, isn't it worth a try?

If we honor this incredible gift of our minds, but take the time to condition it away from constantly chewing on immutable information, we may find ourselves with a vibrant, creative life. People will often say to me, "I tried. . ." (insert any quietive practice you think you don't like) ". . .and I can't clear my mind, so it doesn't work for me." Or "I tried that and I couldn't sit still." In the kind of quietive work I teach, sitting still isn't the goal, nor will I ever instruct you to "clear your mind". Think of the irony of this. We have spent our whole lives developing our ability to think, solve problems, communicate. . . But now we think we're going to make that lifetime of conditioning stop by sitting down and willing it so? This is not likely to happen. And why would we want to? Research shows that we might be happier not thinking about the past or future, but we also wouldn't be able to create a lighting design or manage much about life.

Are you ready yet? It won't take much time to get started. We'll go further on this idea in the next chapter, but for now, engage with the project "Getting Started Being Quiet" at the end of this chapter and give it a try!

In the meantime, get ready for a book about lighting that will inspire you to create like someone who cultivates skill in action (one of the many ways the work of yoga is sometimes defined) and channels creative potency. We'll start our journey by considering how we can most accurately comprehend the visual world around us (Observe, Chapter 2). Next we'll dive deep into what is known about light and consider how we can go about knowing more (Inquire, Chapter 3). After that we'll take a long trip through the resources the industries utilize, while strategizing on keeping up with its constant innovation (Gather, Chapter 4). Then we'll begin the process of coalescing this information into your own choices (Choose, Chapter 5). After that we'll consider how the artist turns choices

Observe

We'll begin Chapter 2 by jumping right into a project designed to hone your ability to observe thoroughly.

Project: Lighting Moments

Why?

One of the lighting designer's most important tasks is to use light to affect others. In order to do that, they must gain an awareness of light around them and its impact. In this project you observe, document, and reflect on single moments when the light in the experience affected you in some way. In the beginning, favor moments in which the light is naturally occurring (rather than designed), because those take more practice.

What?

Explore two questions:

1. What is the physical reality of the moment? In other words, what specifically caused this experience? Where is the light coming from, what is it landing on, and what is its color, texture, and quality?
2. How and why does it make you feel? This is usually the harder question to answer when you're just starting out, but rest assured, there

DOI: 10.4324/9781003022725-2

is almost always an answer. If it grabbed your attention, there was an effect. For example, a sunrise that leaves you feeling invigorated, perhaps because of the vibrant red. Or maybe a movement of shadow in an unexpected place that leaves you feeling anxious. It may feel hard to answer this question at first, but the effort will be time well spent.

How?

This works well as a class exercise on a discussion board, or organized on social media. Upload a picture, answer the two questions, then view other participants' submissions and comment on them. Sharing or even capturing the images is not absolutely necessary in order to meet the basic objectives of the project, but doing so can spark good conversations and be the beginning of a useful personal library of images. Simple journaling in a notebook about an experience is also quite sufficient.

Measuring success: A progressive depth of analysis over time is the best indicator of success. If you're having trouble analyzing the impact, ask yourself why you noticed the moment in the first place. What were you feeling before you noticed it and what were you feeling after? What about the experience might have caused that change in feeling? Over time, this gets easier and your ability to detail your experience will grow.

Timetable: In the beginning, set a goal of one entry every couple of weeks. Eventually you will find yourself doing it automatically and be amazed at what was always there. Until that happens, use deadlines. If you haven't had an experience as the deadline is nearing, make some time to find one.

Always honoring my teachers, this project has evolved from one that James H. Gage called the "Lighting Diary".

Quietive Practices and the Creative Process

Quietive practices are more commonly known as contemplative practices, but I think this can be a bit confusing. In the way that I have learned and instruct quietive practices, we aren't meant to be contemplating things when we practice. So I have borrowed the word "quietive" from one of my teachers, Al Kaszniak, who holds an unusual pair of titles: professor emeritus of neuropsychology and Buddhist Sensei. For me, good

contemplation is a cherished effect of quietive practice, but not something we do intentionally when we practice.

The seemingly most popular contemplative or quietive practices are yoga and meditation, but there are many more. The Center for Contemplative Mind in Society (contemplativemind.org) has a tree graphic that lists other activities you may have heard of: tai chi, Aikido, qigong, even dance and some others you may not have realized can have similar results: singing, journaling, visualization, volunteering.

Not all of these activities will achieve the results that I'm suggesting we – as artists – aim for, so let's define what we're trying to accomplish.

If you've tried one of these things and thought it wasn't for you, what if you considered the long game? Think of these activities not as magic pills, but as practices, or maybe in the same way you might see your favorite exercise or recreational activity. When you first started out, was it fun *every* time? It was probably hard sometimes, but you kept doing it. Why?

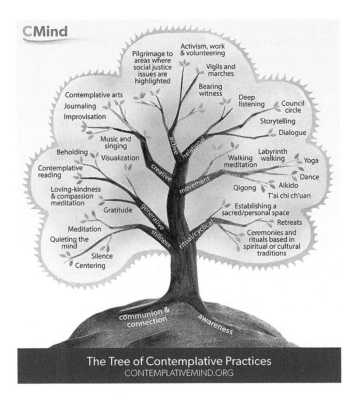

Figure 2.1 Tree of Contemplative Practices

The Center for Contemplative Mind in Society

Meditation and most quietive practices take some time to pay off too. *Most of the time, most people* will feel calmer when they are done, but it is also true that it will often feel hard, especially if you are a fast-moving, always-busy person like me. The rewards, however, are many and they get richer over a lifetime. Some of them are obvious and don't take many cycles of practice to attain, like feeling calmer, having less anxiety, having better moods, and better sleep. The longer you keep it up, the more profound the effects.

It is also important to consider that the reason we talk about both meditation and meditative *practices* is that meditation as we commonly think of it isn't for everyone or even for every situation. For people who have serious anxiety challenges, or even in a moment when the nervous system volume is turned up, sitting still can worsen anxiety and agitation. Very experienced meditators may be able to effectively sit through that, but for others, there are better options. In the project "Getting Started Being Quiet" in the last chapter, you noticed that I suggested walking as an option. In fact, walking meditation is standard practice in some traditions. Done with the same intentions, many kinds of movement may become meditative on their own.

Consider this finding from a meta-analysis of MRI studies published in *Biomed Research International*:

> Results of the present ALE [activation likelihood estimation] analysis suggest that meditation practice induces functional and structural brain modifications, especially in areas involved in self-referential processes, including self-awareness and self-regulation, as well as in areas involved in attention, executive functions, and memory formations.
>
> (Boccia et al. 2015, p. 14)

Meditative practices actually re-wire your brain and may make it work better. It didn't happen the first time you tried it, though, so give it another chance.

So what intentions are we aiming for? Our first objective as med-itator-creatives is interrupting repeating thoughts. You can relate this to another colloquial term we've been hearing a lot lately: "creating band-width". When the mind is thinking, it is doing exactly what we have trained it to do: think, plan, mull, solve. There's no reason to judge or set up conflict with that. But most of the time, we don't have much influence over what it decides to think about and it will keep trying to work on a problem even when there is no new or useful information to consider. "What am I going to have for lunch?" or "Why did that other driver look at me that way?" or "I wonder what was bothering my co-worker this morning?" These are

CHAPTER 3

Inquire

Light in Art

Impacts of Light for the Artist

If you have taken an art class in your past, you may have gotten a list of Elements or Principles of Art or Design, or some list of things the teacher thought was the crucial vocabulary for talking the visual experience. We're going to make our own lists for light, but let's start with a list of three broad things about light that I think visual artists have managed to harness. I'll call these *Composition*, *Contrast*, and *Tone*.

Ponder Hopper's *Nighthawks* (Figure 3.1). Pretend for a moment that you have special powers and can switch on *work light* or the sun. Do that in your mind's eye and imagine the event fully exposed. If it were brightly, uniformly, and colorlessly lit from corner to corner in the viewing frame, what would be visible? Now turn that light off and experience the painting as Hopper choose to reveal it. What light is left? And in a broad way, what is light contributing to your experience of the depicted moment that *wasn't* there when everything was uniformly exposed?

There is no one right answer here and you may note many, many contributions of light. I'll tell you what I experience. The varied intensity of the light in different areas of the picture creates a compelling *composition*. Relatedly, that same variation creates a *contrast* between the event taking place and the area where people are not. The high *value* of the warm interior light contrasts the dim, greenish light outside, which itself

DOI: 10.4324/9781003022725-3

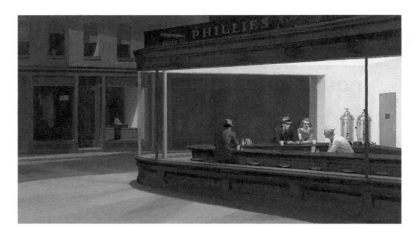

Figure 3.1 Nighthawks, 1942, Edward Hopper
The Art Institute of Chicago/Art Resource, NY

creates a *tone*, or evocative atmosphere. The feeling I have is one of curiousness – "What's going on here?" "Why are these people gathering in that place when the area around is at rest?" Light is probably not the only thing influencing the tone. There is plenty about the objects to evoke, but the point is that a sense of light is one important tool that Hopper used to accomplish whatever we think he accomplished.

Take a break from reading for just a moment and use a search engine to get a page of "famous paintings" or "art masterpieces". I think you will find that any time there is a sense of light in the work, a certain kind of Composition, Contrast, and Tone are apparent. If those things are difficult to talk about in a visual experience, chances are that a sense of light isn't being utilized. The moment you deliberately place light in an experience, you will construct a composition, create contrast and evoke some sort of tone.

Engaging the Observer

Why do we care? Let's first draw a distinction between *personal taste* and *effective choices*, which are not the same. As artists, we probably *should* have taste preferences. But when we take on the responsibility of *design*, taste is only part of an equation. The design equation favors effectiveness. Design is by definition *purposeful*, *deliberate*, and *intentional*. There can be a sort of laziness in pulling the taste card when defending a choice by saying, "I just really like this color." I'm OK with it when all observers consider it a self-evident truth, like in a concert when a lighting

Figures 3.6 and 3.7 The Picture of Dorian Gray "Ghost Pyramid" under work-light and under production conditions. Shown: Dani Dryer and Matt Bowdren

Photo courtesy of Christopher Johnson and The Rogue Theatre; photo by Tim Fuller

This is one reason the selfless and noble "old school" assertion of Jean Rosenthal's day, that lighting should be felt and not noticed, for many has lost some of its nobleness. If we expect people to spend money on the work we do, it can't be *too* invisible. I'm not suggesting that it should

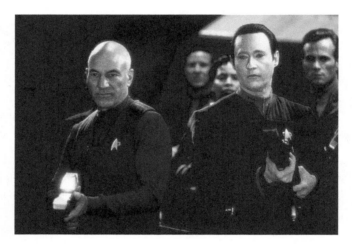

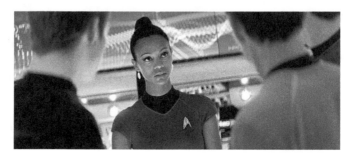

Figures 3.8, 3.9, and 3.10 Star Trek: The Motion Picture (1979), *Star Trek: First Contact* (1996), *Star Trek* (2009). Shown: Leonard Nimoy, William Shatner; Patrick Stewart, Brent Spiner; Zoe Saldana

Paramount Pictures/Photofest ©Paramount Pictures

influences, or simply uses. At the top of your worksheet, put the words "Function, Impact" along with a couple of these alternative words and mark the one that makes it clearest to you. The operative difference is that this is a list of broad, core things that *light does* or *can do* to support a feeling, theme intention, or story; not what you as the designer or technician *can do TO light*, at the practical level, to achieve those things. We'll explore that other list of controllable qualities, properties, and variables in Chapter 4.

There are a couple of significant evolutionary shifts in this vocabulary of Functions or Impacts that might be worth noting. Remember that McCandless started us off with four: visibility, form, naturalism, and mood. Parker and Wolf added "reinforcing theme", Pilbrow added "information", and Gillette more recently added "given circumstances". As lighting as an art form matured, these adaptations serve to expand the role of light in supporting and enhancing the story. Essig eventually expanded her list to give us a banquet of the things light can do: Visibility, Environment, Image, Mood, Style, Modeling Form, Defining Space, Visual Focus, and Pacing and Rhythm. These are rich words that signify the growing depth of the potential impact of light. Do any resonate with you?

The Functions/Impacts and Qualities of Light as we are discussing them evolved in the theatre, but let's survey how they are talked about by some of the teachers in our other entertainment fields, beginning with **film**. Lighting in film is designed by cinematographers or DPs, which stands for "Director of Photography". Cinematographer David Landau asks in his book *Lighting for Cinematography*: "What does lighting do for cinematography?" and answers with these pairs of words: "Illumination and Selective Focus", "Illusion of Reality and Modeling", "Evoke Emotion and Create Mood" and "Pictorial Beauty" (Chapter 1). These are excellent pairings because they acknowledge the interconnectedness of the ideas. For instance, you'll find it hard to talk about Selective Focus without talking about Illumination. And one of the reasons to have good Modeling is to enhance the Illusion of Reality. And so on.

Though **animation** usually creates images with virtual light rather than light from an actual source, light is still a big contributor to the success of their work. In *Lighting for Animation*, Senior Lighting Technical Directors Michael Tanzillo and Jasmine Katatikarn describe "The Role of Lighting" in three primary ways: "directing the viewer's eye"; "shaping objects to create visual interest"; and "to create mood that assists the storytelling" (Chapter 1). Does this sound familiar?

In *Lighting for Digital Video and Television*, John Jackman measures good lighting for **television** in terms of "exposure" (enough light, but not

too much, for the camera), "illusion of depth", and "mood" and "feeling"(Chapter 1). Exposure in this context is a technical term but conceptually not that different from visibility and illumination. Illusion of depth is another way to look at modeling or form and it takes on a special importance in television because the device through which we experience the creation is quite literally flat.

In **architectural** lighting, we find an even broader set of practical considerations with artistry threaded through them. The IALD (International Association of Lighting Designers) Lighting Quality Venn Diagram starts with three broad categories of concern: "Human needs", "Economics, energy, efficiency and the environment", and "Architecture and other building- or site-related issues". There are several words in each list, mostly practical concerns, but topping the "Human needs" list is again "visibility", along with "mood and atmosphere", and "aesthetic judgment". Under "Architecture and other building- or site-related issues" we once again find the familiar words "form", "composition" and "style" (website, "Quality of Light" page).

Every field makes use of light in similar ways, but with a slightly different perspective. We'll next look at the commonalities and, as we do, I encourage you to reference your worksheet and perhaps note some things that relate.

"Visibility" or "Illumination" top almost all lists across fields, and for good reason. If the observers can't see what we want them to see, it's hard to accomplish much else. This should always be thought of on a continuum, though. The observer needs to see, but the designer, cinematographer, and/or the creative team decides what and how much they see with regard to the creative goals.

Consider the 1966 Broadway thriller *Wait Until Dark*, masterfully turned into a 1967 film with cinematography by Charles Lang. The story is about a blind woman preyed upon by a group of con artists who think her husband brought something valuable into the couple's apartment. Throughout the story, the men use the fact that she can't see to deceive her, but they fail to consider how her situation enables her to take in information in other ways. As she begins to realize what is happening, she knows that the only way she can gain an advantage is to eliminate all light in the apartment. This script can be an adventurous lighting designer's dream to work on. The team has to spend a lot of time thinking about what the audience needs to see and when they need to see it. Light and the absence of light heighten the story. At a pivotal moment in the film version, the darkness is sliced open by the light from the refrigerator as its door swings open, but our heroine doesn't know it. Then she hears the rattle of the glass in the refrigerator and realizes she forgot that one light

source. . . The creative team has to make decisions about how long the audience can sit in the dark and how dark it can be as this terror plays out. Audiences get restless when they can't see what they want. But if the team decides to let them see too much, they sacrifice the impact of the refrigerator light cutting into the heroine's safe darkness. The questions around how to lay out the journey of light should always be answered by what best will achieve the artistic intentions.

"Ensuring that we see what we need to see" is of primary concern to the lighting designer. What word did you pick to use for this? I enjoy the poetry of *Illumination*, but my experience is that *Visibility* is clearer. The word *Exposure* comes in handy too. A stage director once gave me a note: "They feel really exposed." By that he meant there was too much visibility for the intimacy of the moment.

The idea of "directing the observer's attention" is prominent across our references as well. In an in-person live experience, the audience inherently has a larger *field of view* than they do with the controlled frame of the camera. This concept is most commonly called *Selective Focus*, but you'll need to spend some time clarifying for yourself what differentiates it from Visibility. Parker and Wolf solve the overlapping nature by merging them into "Selective Visibility". Laudau calls them separate things, "Illumination and Selective Focus", but talks about them as one topic.

The word *Mood* is one of those words that may seem simple but defy definition. This is what I would use for "assist in making us feel what the story/

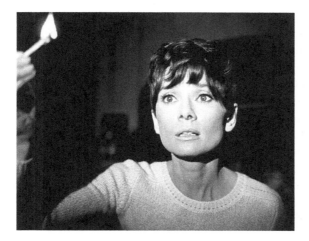

Figure 3.13 Wait Until Dark (1967), directed by Terence Young. Shown: Audrey Hepburn

Warner Bros/Photofest ©Warner Bros

theme/intention intends for us to feel". Mood and Visibility can sometimes battle with each other, especially when equipment is limited. When you hear someone say, "it's just a little too moody", often the reason they think that is because they can't see what they want to see. Conversely, when it doesn't feel "moody" enough, often it's because there is too much light or exposure.

The concept of *Revelation of Form* or *Modeling* or *Modeling Form* is on almost every list in some way, but is also difficult to describe. It is trying to get at what I called "ensuring the three dimensionality of the objects and the depth of the environment". This is important for many reasons, such as that it makes the picture seem more real, but also because it makes it more interesting to look at. If you have ever used a camera flash in a dark environment and were disappointed with the result, this could be one way to understand it. Bright light from the observer's direction ensures that the subject is visible, but eliminates all shadows, perhaps making the subject look like it was painted on cardboard. Cameras are so much more sensitive to light now that we rarely have to use flash anymore, but this flattening can easily happen on stage, video or film if you don't consider Form in your design, or if you favor Visibility by leaning heavily on light from the front (like a camera flash does). In considering an effective word, I've found that Modeling seems to work well in communication between seasoned visual artists, but is the source of confusion for first-time learners. The word Form doesn't seem to have much meaning on its own, and though Revelation of Form is beautifully poetic, it doesn't flow well in a conversation. I haven't seen this on anyone's list and I'm not sure where it came from – I think it may have been one of my students – but the word I've come to appreciate is *Sculpting*. It is a word that even people who know nothing about lighting can immediately understand, possibly because it echoes the impact of the three-dimensional art discipline of sculpting.

Closely related to the ideas of revelation of form, sculpting, and defining the space is *Composition*. While the word Sculpting usually makes us think of individual objects, a cohesive Sculpting of all objects in a space will ultimately sculpt the space itself. Done well, it will construct a certain kind of full visual Composition. The word composition is technically a visual art term that has to do with the arrangement of objects. Arranging objects in an entertainment setting is usually done by the director or scenic/environmental/production designer, but how the lighting designer approaches Selective Visibility and Sculpting will impact how the whole composition eventually appears to the observer. And so Composition is the word I like for the task: "Arrange compelling visual images in the observer's field of view."

After these common concepts, the vocabulary begins to scatter. The next big thing we try to articulate is the way in which lighting can support the story, theme, or creative objectives. McCandless got the ball rolling with *Naturalism*, which attempts to describe the way that light would

training, traveling. I didn't know what "musical theatre" was until I was 15 or 16, but I knew all my favorite Disney movies had catchy songs. I was (am) terrible at traditional art. My third-grade self-portrait haunts me to this day. I "played" the trumpet for maybe six months. I learned how to read music on the back of a Denny's placemat, the only place open 24/7 in my hometown. My first cast album was a pirated copy of *Spring Awakening*.

I'm here to tell you that it's possible to come from somewhere that feels like nowhere, and get to exactly where you want to be.

I went to a university in-state because, frankly, I didn't have anywhere else to go. It turned out to be one of the best decisions I have ever made. Our professors emphasized the importance of the summer stock experience, using our time away from school to apply our skills in the professional world, expanding our horizons, and bringing new knowledge back to the learning community. I was offered a position as a lighting apprentice at the Santa Fe Opera during the summer between my junior and senior year. It changed everything. I spent the next five summers at the opera as a lighting supervisor, serving as an assistant for visiting designers. I cannot remove myself from the valuable experience of this job. It turned me into the associate I am today. The opera is in a unique position to provide young professionals an opportunity with positions we might not be completely ready for; a safe place to make mistakes, trip over ourselves, and grow into the too big shoes handed to us. Many of us lived by the mantra, "fake it 'till you make it," and I dedicated myself to making it, fighting tooth and nail, standing up for myself, and figuring out what kind of strength I needed to be the professional I aspired to be.

And now? I can't believe it, but I sometimes work on Broadway. I sometimes launch National Tours of smash hit musicals. I sometimes work on brand new musicals. I sometimes spend hours drafting, generating paperwork, answering emails, and making phone calls. It's the best.

What I wish I had known when I was a student. . . I wish I had known that this job that I love (being an associate lighting designer) was an actual career path. Make sure you explore things outside your school, because no matter how good they are at what they're teaching, there is a world of opportunity out there that can't fit in a classroom. I wish I had known that opportunity does not exist equally for everyone entering the workforce at the same time. When I arrived in New York, I realized that students coming out of the traditionally high-ranking, high-output theatre schools, or certain summer stocks, had a

leg up for success in this market. They had been groomed for these jobs in ways that my school just couldn't have done for me. That was a shocking realization, and led me to believe I didn't belong here, that this was all a mistake. On the other hand, it also brought out that tenacity I mentioned earlier; now I had to succeed, and I would find a new strength that this inequity had made me see as a weakness. Draw on your tenacity or stubbornness and know that plenty of people before you have closed these gaps. There are no guarantees of success in this business, but determination counts for more than anything. And even though I write this during the pandemic, when almost all live theatre is shut down, I'm one of the lucky few still making a living.

My best advice to you . . . Make mistakes. Live with them, don't let them consume you. Accept change as it comes your way, see where it takes you. Welcome quiet moments, give them space. Allow them to fill the dark corners you ignore during adrenaline filled hours. Allow your strength to be balanced by your weakness. They work together in beautiful ways. Reflect on the spider web of people who made you who you are today. Remember where you came from, to see where you're going.

Concerts and Music Touring

Concerts and music touring have similar roots to traditional live performing arts, but now mood carries at least as much weight as illumination, and often more. It's not that people attending concerts don't care about what's on stage – if that were the case, no one would bother with *image magnification* (i-mag), those live close-ups on giant screens – but seeing the performer is just the beginning. Spectacle is often expected. Depending on the style of the artist and how much money you have, sometimes the more spectacle, the better. These are generalities, of course, since spectacle is a lot less called for if you're lighting a symphony or a chamber ensemble, but even in those traditional styles, the visual environment is becoming more attended to.

When touring with bands or music-centered shows, there can be a lot of variation in venues. The main reason bands tour is to sell their music, so realize that the quality of the sound is the highest priority. The lighting designer must be resourceful in order to recreate stunning visuals under a variety of circumstances. Many lighting students want to go into this kind of lighting design but there aren't a lot of programs that train specifically for it. Never fear, though, any good lighting training program can get you there. Our next Pro-perspective is from someone who hasn't been in the business for very long, but that's why I wanted him to give his perspective. As he writes this, he may only be a few years ahead of you but he's figured some things out. Meet Sam Schwartz.

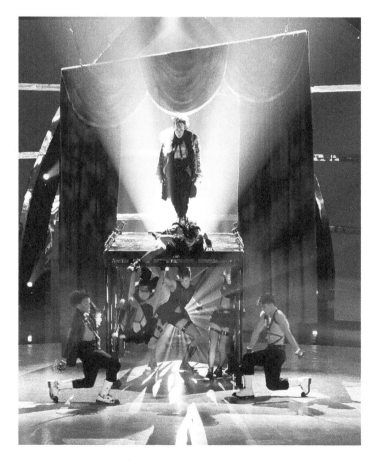

Figures 3.16, 3.17, 3.18, and 3.19 (Continued)

Pro-perspectives: Travis Hagenbuch, From Theatre to Television

On my first day as an intern on a TV show after moving to Los Angeles – fresh off a theater education – I was surprised to see the LD watching a music rehearsal with his back to the stage. It turned out he was watching a video monitor, since the TV picture was more important than the live event itself. My curiosity piqued, I dove in and learned everything I could about making live event TV, most of which I learned on the job.

Making the leap is not difficult in terms of skillset. Theater lighting knowledge is assumed and is a great foundation for a transition into live TV. Priorities tend to shift, but the basics are familiar. While carefully chosen colors and *gobos* sometimes fall by the wayside, that effort is shifted into a further emphasis on calculated angles, color temperature, and intensity to keep cameras balanced and talent looking their best.

I found it invaluable to learn some ground rules first, taught to me by mentors on award shows like *The Oscars* and *The Emmys*. While everyone loves the visual impact of a big wide shot – also most familiar to theater LDs with a tech table view – much of a show like *The Oscars* actually exists in close-up shots of people. The details in those shots, from faces to backgrounds, are hugely important. Making faces look their best for tight shots means, among other things, mitigating the hard shadows inherent to long-throw theatrical fixtures and carefully controlling color temperature. While maybe not intuitive to the uninitiated, the practice becomes familiar after hours spent staring at a video monitor, learning to identify and correct subtleties.

Once the basic rules of controlling light for camera are understood, the possibilities to break them and be more theatrical are endless. Color and exposure can be manipulated to support any concept if appropriate for the moment. To quote Lady Gaga at a long-ago rehearsal, "Make me look beautiful, then puke all over it."

Days are long, but overall time is short. A large music show with 25 performances is akin to teching a three-hour, arena-sized musical in three days before your one and only performance gets broadcast to millions of people. It's exciting, but daunting. The tight schedule means that many things happen simultaneously during rehearsals. Time doesn't allow for the specificity of command line syntax, so while the LD is reviewing the previous rehearsal take with the director, producers, network executives, and artist, the programmers are furiously fixing cue notes in real time. The rest of the team

are addressing focus notes, making sure the next performer's look is ready for rehearsal, and probably picking up dinner for those who won't leave the room for hours. It is a machine whose efficiency only works when those running it have the experience to intuitively know the process and be quick to identify and solve problems. When it's all over, there's no rush quite like the ten-second countdown leading into the words, "And we're live!"

Architectural Lighting

In **architectural** lighting, function rises in priority as it concerns itself with physical structures and the space inside or around them, as well as the observers and the users. In this way, observers become part of the environment being lit. This may sound like immersive arts and indeed there can be some overlap, but usually architectural lighting is meant to remain for a long period of time, whereas immersive arts are usually event-based and do not necessarily attend to the structure the event is taking place in. Adequate light for particular activities such as working, reading, eating or browsing may have to be considered in architectural lighting design.

Let's pause for a fun project that will get you noticing architectural lighting.

Project: Go Shopping! (But you don't have to buy anything!)

Why?

This adventure will increase your awareness of how light is used in particular environments for specific objectives, in this case, a shopping mall or a commercial area like downtown. If you do not have access to such a thing, one suggestion would be to go your local mall's website or the website of an area of neighborhood commerce, like "Downtown (fill in an interesting city)". Find the names of the stores or restaurants in that area, then do an image search of those names until you find some that give you a sense of light in those places.

What?

Choose a major shopping mall with department stores or an area of town that has a wide range of business offerings. You will find more variety in

the lighting if you choose an indoor space; however, outdoor spaces work if you visit them after the sun goes down. If choosing a mall, you will have more fun and have more to ponder if you choose one that is relatively new. Older malls tend to be more generally lit and less designed. Compare and contrast three specialty stores that are different from one another, as well as the common areas, such as the hallways, entrances, food courts, or streets.

How?

Reflect on the following questions:

1. What is the intent of this store (or areas)? What are they selling and to whom? How is light used to help accomplish that?
2. Is the lighting coordinated effectively with other visual or controllable elements such as the environment, the displays, the sound, or the costumes/uniforms of the people working there?
3. Describe the special atmosphere of the store (or area). Does it affect you emotionally? Aesthetically? Do you find it comfortable? Does that serve the intent of the store or not?
4. Go back to the "Your Language for Light" words that you chose. How are those lighting imperatives addressed in this store (or area)? Are different parts of the store (or area) lit differently? Why might that be? Is light used in an apparently intentional way? Is light used successfully?
5. What would you change if you were the designer and why? Remember to connect your ideas back to the specific purpose or intent you believe the stakeholders were focused on – if you want to change something just because you don't like it, but in a way that doesn't necessarily serve the intent of the store, ask yourself why.

Measuring success: Wrestling determinedly with the questions until you have a thorough answer is the only marker of success on this one. There are no right answers, only thorough observations and logical conclusions. Much like the lighting moments, once you have completed this assignment, every time you experience a designed retail space, you'll see things you never realized were there.

This project has evolved from one my teacher James H. Gage called: "The Mall Project".

Take a Breath: Reflections and Trailheads

As we close on Chapter 3, I invite you once again to reflect on and allow your memory to etch into your consciousness what was covered. You'll need a way to make notes and ideally be in a quiet, comfortable place. After you read this paragraph, start by closing your eyes and bringing your attention to your breath. Take just a few inhales and exhales, to settle and make space for these reflections. After you've done that, read each reflection question one at a time, closing your eyes for another breath or two to find what surfaces. Then jot some notes, and when you're ready, move to the next question.

Reflections:

- Light in art: In what ways do visual artists use light in their creations? How can light help tell a story?
- Light in live performance and entertainment: Why should we bother to design light?
- Your language of light: What words will be *yours* for "What Light Can or Should Do?" How do those concepts relate to the art forms of live performance, film, television, animation and architectural lighting?
- Lighting design across the industries: How do each of these industries incorporate light into their creations?
 - The traditional live performing arts
 - Concert and music touring
 - Live immersive, non-narrative, and/or experiential situations
 - Television
 - Architectural and architainment
 - Themed entertainment
 - Film
- Pro-perspectives: What can you take away from each of these?
 - Jessica Creager, Associate LD in NYC
 - Sam Schwartz on touring with the band
 - Scot Gianelli on exploring new opportunities for performance
 - Travis Hagenbuch on transitioning from theatre to television
 - Rachel Gibney on using design principles in architecture
 - Steven Young on taking themed entertainment all over the world
- The artistic and aesthetic standard-bearers: USA, ASC, IALD, TEA . . . Which organization or organizations will you look to to set the standards for your work?
- What ideas in the chapter do you want to know more about?

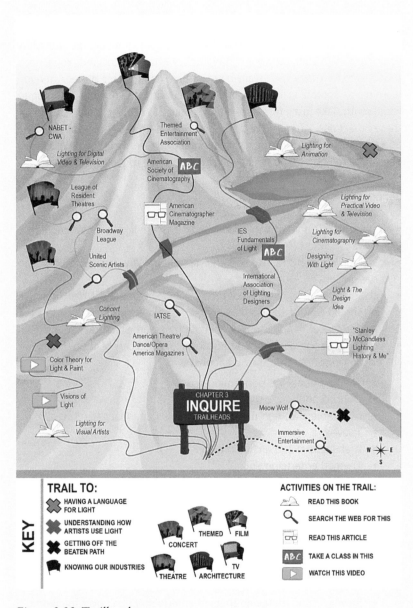

Figure 3.22 Trailheads

References and Resources

Essig, Linda. "Stanley McCandless, Lighting History, and Me." *Theatre Topics*, vol. 17, no. 1, 2007, pp. 61–67, doi:10.1353/tt.2007.0008.

Gillette, J. Michael., and Michael J. McNamara. *Designing with Light: An Introduction to Stage Lighting*. Routledge, 2020.

Gillette, J. Michael. *Designing with Light: An Introduction to Stage Lighting*. Mayfield, 1978.

International Association of Lighting Designers. "Quality of Light." www.iald.org/Advocacy/Advocacy/Quality-of-Light.

Jackman, John. *Lighting for Digital Video and Television*. Routledge, 2020.

Katatikarn, Jasmine, and Michael Tanzillo. *Lighting for Animation: The Art of Visual Storytelling*. Routledge, 2017.

Landau, David. *Lighting for Cinematography: A Practical Guide to the Art and Craft of Lighting for the Moving Image*. Bloomsbury, 2019.

Marcus, Joan, joanmarcusphotography.com.

McCandless, Stanley. *A Syllabus of the Course in Stage Lighting*. Whitlocks Book Store, Inc., 1927.

Parker, W. Oren, and Harvey K. Smith. *Scene Design and Stage Lighting*. Holt, Rinehart and Winston, 1963.

Pilbrow, Richard. *Stage Lighting*. Drama Book Specialists, 1970.

Key to Industry Icons:

 Theatre/Traditional Performance

 Film

 Television

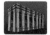 Architecture

 Concerts

 Themed

Key to Source Icons:

 Incandescent

 Discharge

 LED

ELLIPSOIDAL REFLECTOR SPOTLIGHT (ERS)

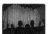
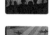
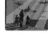

The *ERS* is probably the most prized lighting instrument of the theatre industry and is used at least a little in most other applications as well. Its highly evolved optics make it precisely shapeable and flattering on all skin tones. An ellipsoidal-shaped reflector efficiently collects all light particles and projects them through a gate and then out through a lens or lenses. This allows for the shape of anything placed in the plane of that gate to be projected clearly in the pool of light. Specially designed *gobos* or *templates* (thin pieces of metal) can be inserted to project shapes or text. Unwanted light can be precisely trimmed with the *shutters*, which are metal blades inside the instrument, at the gate. When maximum control is desired, an ERS is a great choice. The downsides compared to other kinds of conventional instruments is that they have more moving parts, so they take longer to focus and can require more maintenance and repair. They also cost more to manufacture, so they are more expensive.

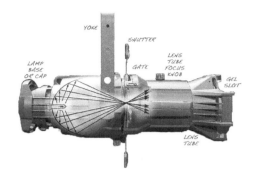

Figure 4.5 The inside of an ERS

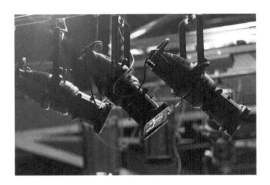

Figure 4.6 Ellipsoidal Reflector Spotlights (ERS)

© aerogondo – stock.adobe.com

FRESNELS

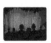
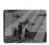

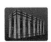

Fresnels have been around the longest of the instruments still in use. They get their name from their specific lens originally designed for light houses by Augustin Fresnel. This stepped lens gives the beam of light a soft, but still definable shape. The variety of Fresnels are endless, but most are easily identifiable by that lens. They have long been a workhorse instrument of traditional theatre, film, and television applications. They don't have many moving parts so are fast to focus and not terribly expensive. The lens and lamp are fixed together on a plate which you can slide back and forth to change the size of the beam. If you want to shape the beam, an accessory known as a barndoor can be added, but there is nothing built into the instrument that can do it. Even with a barndoor, the lens prevents a Fresnel from being anything but soft. Architecture makes use of the Fresnel lens, but not generally the body that used in other applications.

LINEAR SOURCES

Linear sources are exactly as their name describes and they are popular because they help define space. The surge of LED linear fixtures into the market has made stunning, colorful pictures possible where we weren't used to seeing them before. Linear sources are all around us for more practical purposes as well, like the florescent tubes you often see hanging over your head in offices and classrooms.

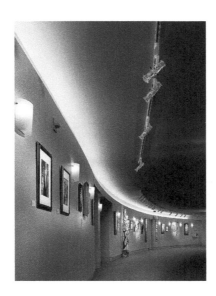

Figure 4.13 Linear sources

Courtesy of ETC

RECESSED AND DOWNLIGHT SOURCES

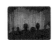

A source can be recessed, but not a downlight, or a downlight, but not recessed. It is also possible for this category and the last to overlap – a recessed, linear downlight for instance. You may have experienced any combination in a hallway of a public space. Recessing a light source protects it from damage and shields the user from looking directly at the source, making them an attractive choice.

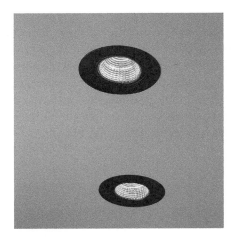

Figure 4.14 Recessed downlights
Courtesy of ETC

TRACKLIGHTS

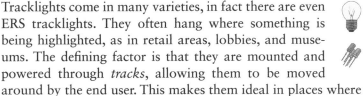

Tracklights come in many varieties, in fact there are even ERS tracklights. They often hang where something is being highlighted, as in retail areas, lobbies, and museums. The defining factor is that they are mounted and powered through *tracks*, allowing them to be moved around by the end user. This makes them ideal in places where the objects in the room will move around long after the lighting designers and contractors are gone. Know that each track has an electrical capacity and that if you try to jam too many lights on one track, they will not come up to full brightness.

Figure 4.15 ERS tracklights
Courtesy of ETC

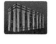
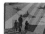

DAYLIGHT

No single light source takes up as much room in the Illuminating Engineering Society's *Fundamentals of Light* textbook than daylight. For architects, understanding the benefits and downsides of incorporating daylight into a design is a deep topic. It can bring warmth, a natural feel, and energy savings into a design. Daylight has been connected to health benefits and more accurate color fidelity.

The downside is that daylight is difficult to control, somewhat unpredictable, and in some circumstances can make energy costs higher. Traditional performance lighting designers would love to have daylight as an option, but the lack of control is usually a deal-breaker in story-based design. It is possible to use it in a theatrical experience, however, especially when experiences are non-linear or in moments when control can be loosened. For instance, at the Santa Fe Opera, the semi-enclosed audience seating area faces a stunning desert landscape behind the stage. Audience members are sometimes treated to spectacular pre-show sunsets when they can be plausibly part of the opera about to be experienced. Film and television shoots make use of daylight when they find it advantageous to do so. In fact, the term *Magic Hour* is a film industry phrase used to reference that short window of shooting time around sunset when atmospheric light is most enchanting.

Figure 4.16 Filming with daylight
© bepsphoto – stock.adobe.com

Some questions to consider if you have the option to incorporate day-light into your design. . .

Where will the sun be when the audience is experiencing the event or the scene is being filmed? Remember that not only does the sun move over the course of the day, but its trajectory across the sky and the times that it rises and set change day to day.

How predictable is the weather, and can you make the design immune to the sun becoming blocked? Clouds unexpectedly moving in can delay the schedule if the sun is being relied on. There has to be a plan B or the budget must have room for nature's whims.

Is this an indoor or outdoor experience and *how important is that daylight to the design?* Concern for nature's whims can be mitigated if you're filming in an indoor space and using light through a window as an enhancement rather than relying solely on it for illumination. In that case, if weather interferes, you may be able to quickly recreate the desired effect with artificial light.

How does the use of daylight impact energy consumption? This question applies most to architectural lighting. If the space is experienced primarily during the day in temperate climates, using daylight can reduce the amount of electricity needed for lighting. But if the space is used primarily during the day in a hot climate, energy saved on lighting could be lost to air conditioning costs.

Will objects in the space be affected by sunlight? The effect on collections (art, artifacts, animals, etc.) must be carefully researched when using daylight. Sunlight can be destructive to delicate objects or stimulate plant growth, so you must always do your homework.

Take a Breath: The Lighting Brushes Reflections

Take another moment now for a breath to let this section sink in before we take on Electricity. As always, take a comfortable seat, close your eyes to settle, then reflect and make some notes on the following prompts, one at a time:

- The controllable qualities, properties, attributes, parameters or variables of light
 - What are the Properties words that resonate for you that describe what we do to – or control – about light?
 - How will you decide what light can and should do for a particular design?
- The common sources of light: incandescent, discharge, and LED
 - What kinds of considerations matter when choosing among them?
- The conventional, established lighting brushes: ERS, Fresnel, PAR, cyc/strip/open lights, soft light, linear, recessed, downlight, tracklight, daylight
 - How will you decide which to choose?
 - Are there ones that are new to you that you'd like to try?

Powering It All: Entertainment Electricity Basics

Take some deep clearing breaths before this next expedition. Some people love electricity and some people find it dry. If you find it exciting and it comes easy to you, consider sharing your enthusiasm to help your fellow learners connect to it. If you find it laborious, know that many students before you have felt the same way and got through it just fine.

I think it might help to consider for a moment why we even include electricity in a study of lighting, and what your needs are or will be around this topic. As a lighting teacher, I have always struggled with how much of this to teach and if you are a lighting teacher, you will have to spend some time figuring this out too based your student population's needs. In traditional technical theatre training, we are teaching students to use specialized tools and reconfigure those tools in new ways for every production or event. That should be a relatively straight-forward task, but in my experience, the little bit of operational knowledge of electrical materials that students tend to get in their first days in the theatre is enough to enable them to get creative with electricity but not enough to teach them when they shouldn't. As soon as the student learns how to put on a connector, wire-nut a sconce to a cable on the back of a *flat*, or connect lamp bases on a flying *chaser* sign, they have enough knowledge to get into trouble. The directors and collaborators around them will encourage them to figure out how to do things no one has trained then to do, but academic organizations do not always have the necessary technical expertise available, nor do higher education organizational systems provide for the comprehensive training necessary to ensure that those things are done correctly. As the demand for training grows beyond the traditional walls of a theatre into the broader world of entertainment – all those other industries we've been talking about like film, architecture, concerts, theme parks, immersive experiences – more technical expertise is necessary.

In classes, I tend to err on the side of teaching students more information than less – I call it their electrical understanding empowerment and I start with the atom, which understandably makes my expert friends roll their eyes. I do this because I don't know if they'll have access to additional electrical training when they need it and I want them to feel like they have a root understanding of it. There are many more resources now though than when I started teaching, and many more experts aware of this dilemma writing blogs and making themselves available to help. So in this book I'm going to keep a more narrow scope and point you in directions for deeper study. You will have to grapple with what training you need next for your particular goals and how you are going to get it. Some of this information that follows will help you right away. Some of it you may never use again. And some of it will be planted in your mind, ready when you need it.

Who Knows What?

An important disclaimer: I am not a licensed electrician or a certified entertainment electrician. What I know about this dense topic, I know from my experience as a lighting technician, taking workshops, and asking the experts questions. We'll start by identifying who those experts are.

The AHJ or Authority Having Jurisdiction (introduced earlier) has the last word on electrical and fire safety rules. They are usually the local fire or electrical inspector and in many universities are the university fire marshal or risk assessment officer. As I said earlier, the relationship of the AHJ to entertainment venues can be a complicated one since they do not always have thorough knowledge of the entertainment practices and the use of our portable equipment. Their important job is to prevent fires and protect lives, though, so resisting their directives is not a good idea.

Licensed electricians have spent years of study, often in an apprentice type of format before becoming licensed. You will most likely encounter them if you have a facilities-related electrical problem or in some touring venues where there are strict local rules about who can connect touring lighting systems to building electrical systems. *Licensed professional engineers* (PE) have a college degree in engineering and have passed rigorous exams after years of work under other PEs. You are likely to encounter them when planning renovations on a building.

ETCP or "Entertainment Technician Certification Program" *certified technicians* are specific to the entertainment industry. "Certified" is an important difference from "licensed", because it generally has no legal standing. Their certification affirms that the industry has tested them and that it finds them qualified to do technical work at a very high level in the entertainment industry. The program began in 2005 as an effort at accountability within the industry and those that have the certification logged considerable work experience before they were even allowed to sit for the test.

Ohms, Amps, Volts, and Watts/Resistance, Current, Potential, and Power

The cartoon in Figure 4.17 illustrates fundamental electrical terminology. Electricity is generated by a source – the power company, a battery, or a generator – resulting in *electrical potential* or *electromotive force* (expressed as E or V for Voltage), which we measure in *volts* (v). The electrical conductors through which the electricity will flow have *resistance* to that force (expressed as R or Ω), which we measure in *Ohms* (Ω). That resistance slows down the *intensity* or flow of the electricity, which we call *current* (expressed as I or A) measured in *amperes* or *amps* (a). The load draws

(remember, a breaker is an *overcurrent protective* device) have to be sized up (in terms of current-carrying capacity) as well (the cables, the wiring devices, etc.). If the breaker doesn't open the circuit when there is more current being conducted in that circuit than the components in that circuit are able to conduct, then there is a possibility of fire.

Perhaps pause and read that last paragraph a couple more times, especially if you are someone who may teach others, because this is exactly the common launching pad that enables the new technician – someone who has a little information, but not enough – to flirt with disaster. Never try to go around these safety devices (overcurrent protective devices OR grounding conductors) or you invite a fire. If a breaker is tripping due to excessive loads, separate your loads onto other circuits. If you don't have any more circuits, you'll have to reduce the number of loads you are using.

Common Cable and Connectors

Figure 4.20 is a not-as-scary-as-it-looks photo of an old mousepad made by a long ago vendor. It is a handy cheat sheet of information we have already discussed, information we are about to discuss, and information

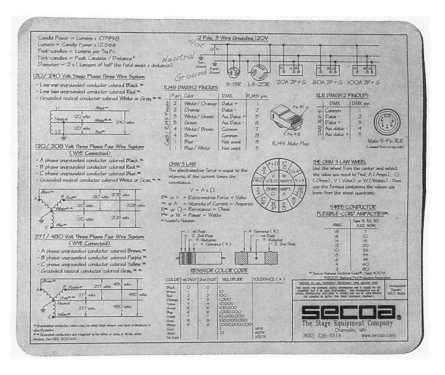

Figure 4.20 Secoa mouse pad with entertainment electrical information

you might like to have in the future. I want you to have it because whenever I look at it, I marvel at how much information they arranged into so compact a space. The lower right title block shows that they meant for it to be shared freely. Maybe snap a picture on your phone and keep it somewhere handy. Barbizon Lighting Company makes a handy *Electrician's Pocket Book* that has a lot of this information in it and more, so you might want to search for one of those as well.

Back to our handy mousepad photograph, in the upper right-hand corner is a diagram of the pin arrangements for common cable connectors, our next topic. The lines across the top are showing you what we called the hot conductor, followed below it by what we called the neutral conductor (the normally current-carrying grounded conductor) or *system* ("Sys") *ground* on the mousepad drawing, and below that, the *equipment* ("Equip") *ground*, which would be the green grounding conductor we've been talking about.

Vertical lines connect those conductor lines down to the pins of most common connectors used in entertainment. The three on the left are the ones you are most likely to encounter: the parallel blade connector (commonly called an Edison), the locking-type connector (which you twist to lock), and the stage pin connector. All three connectors are found in entertainment applications, though the locking-type and stage pin are the ones more commonly used on the traditional portable stage lighting instruments like the ones we surveyed in the previous section. Parallel blade or its counterpart the *T-slot* (which looks similar, but the neutral blade or slot is rotated 90 degrees) are more commonly used on accessories or advanced equipment like we'll discuss in Part 3 or in smaller venues or studios. Both stage pin and locking-type connectors have their advantages and disadvantages and technicians have lively debates about which they prefer. The locking-type connector doesn't slide apart like the stage pin can, but the pins are more likely to get bent. The stage pin has a lower profile and can be dressed more easily in a cable bundle but the pins have to be maintained so that they don't slip apart too easily. This should be done with a tool called a *pin splitter* but a technician in a hurry will sometimes do it with a knife or screwdriver, which can break the pins off, destroying the connector.

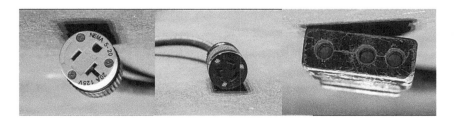

Figure 4.21 Connectors: Eddison, locking, stagepin

As you may have guessed, the last two connectors on the Secoa drawing are used for higher power applications, as indicated by the rating 60A and 100A, whereas the smaller stagepin is rated 20A, typical for stage dimmers. The 60A and 100A connectors are found more commonly on large-scale film or television shoots, but less frequently in theatre. Notice that even though they are shaped similarly, the pin assignment on those does not follow the same pattern as the 20A stage pin connector.

One of the things new lighting technicians ask is, why do we have to use the heavy cables that we use? There are thinner cables that would work, but the code-makers know that we are particularly rough on our portable equipment. Detailed National Electrical Code interpretation is beyond the scope of this textbook, but know that it requires us to use "extra-hard usage" cable for most portable stage equipment which equates to what is called Type SO cable, except in special applications where the cable is protected, in which case "hard usage" or what typically equates to Type SJ cable can be used. These are the bulky cables we complain about. Thanks to our expert advocates on NEC Code-Making Panel 15, the 2020 NEC relaxed the requirements for extra-hard usage cable and now allows us to use SJ in more places. Durability is the goal here. The rules are intended to ensure that cables will survive all the abuse we heap on them. Have you ever read the warning label on a thinner store-bought extension cord like the one in Figure 4.22? If you've done any (maybe all) of those things to a cable in the theatre, now you know the answer to the question that starts this paragraph.

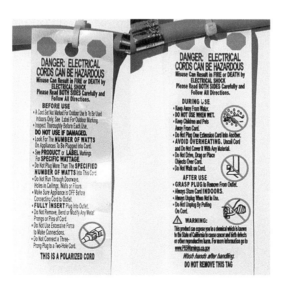

Figure 4.22 Close up of the label on a typical extension cord

Take a Breath: Electricity Essentials Reflections

Allow yourself a final moment of Part 1 reflection so that Electricity can sink in before we move into a much needed diversion in Part 2. As always, take a comfortable seat, close your eyes to settle, then reflect and make some notes on the following prompts:

- Electricity essentials: the "experts", conductivity, circuits, Ohm's law, AC/DC, grounding, the power formula, cables and connectors
 - Who knows what? Who will you call on when you need help?
 - Which concepts apply to the work you are doing right now?
 - Is there anything you've been doing with electricity that you didn't realize was hazardous?
 - What will you need to explore more deeply as your career transitions?
 - Where will you look for the knowledge or training about electricity that you need to grow in your career choice?

If that's not exciting enough for you, the story doesn't end there. This computer light board, which they had named Sam, blew up during previews. Musser, two assistants and two operators scrambled madly to recreate most of the design on manual boards while Steve Terry (whose Pro-perspective you read earlier in the chapter) spent a week soldering Sam back together.

When Tharon Musser passed away in 2005, Broadway dimmed its lights for her. There is much more to tell, enough to fill a book, in fact. I encourage you to check the nearest university library for a copy of *The Designs of Tharon Musser*.

Our next Pro-perspective is by another friend and influential teacher. Richard Cadena has written several books and taught countless technicians. His humor, warmth, and bear hug embrace of all the amazing things technology can do are infectious. I asked Richard to share wisdom on this topic of keeping up. He is another prominent figure never too busy to answer a question.

Pro-Perspectives: Richard Cadena, Author and Trainer: "The Future of Automated Lighting Technology is Here"

Few things in life are more exciting than the anticipation of a live event when the house lights go down, the crowd roars, and you get to press the Go button on the lighting console with the first downbeat. But getting to that level can be challenging, especially when it comes to keeping up with the technology.

Automated lighting hardware has steadily advanced since the technology was introduced in the 1980s, but it might be starting to plateau. Software, on the other hand, is just beginning a meteoric ascent. Heated competition between manufacturers spurred innovation that led to brighter, smaller, and more affordable (relatively speaking) fixtures, and that trend continues today, mostly due to a rapid rise in LED technology. But it's starting to level off. At the same time, the control and management of data for automated lighting systems is becoming increasingly powerful, but also more complex.

DMX has been around since 1986 and it is still the most common protocol used to control automated lighting. Remote Device Management (RDM) has been around since 2006 but is just starting to gain widespread acceptance now that there are a number of handheld tools that can be used with the protocol in order to remotely configure and monitor lighting fixtures. It's likely to be more commonplace in the future, and so will many other software tools.

There's another software tool that has the potential to make a great impact in the design and management of lighting systems. It's a new open protocol called General Device Type Format (GDTF), and it allows users to exchange data between CAD (Computer Aided Drafting) software, fixtures, and controllers so that the job of designing and configuring a large lighting system is consolidated with as little redundancy as possible. Manufacturers can develop GDTF files for their fixtures and put them on their websites where you can download them and import them into a CAD program like Vectorworks. The file then brings with it all of the information about that fixture, like the 3D CAD block and the DMX channel map, that you need to create your plot and design your lighting rig in a 3D virtual format. Once you have a finished design you can export an MVR (My Virtual Rig) file and import it to your lighting console, and the console will then know the position of each luminaire in 3D space and know how to control them correctly.

This may be the beginning of a new age of powerful software tools. Augmented reality and virtual reality will soon become vital tools in the industry to help to speed the design, programming, focus, and operation of lighting and automated rigging systems. Software like ETC's Augment3d and Vectorworks Spotlight AR tools have just appeared, and other developers are likely to follow suit. Technology also exists that could enable voice commands, and it's a matter of time before other new technologies find their way into our little industry. ESTA, the entertainment industry standards-making body, has begun studying the possibility of creating a similar industry standard protocol.

All of this points to the fact that those who are open to learning new technologies and can adapt quickly will be the ones who get to design, build, troubleshoot, and develop systems for live event production. They are also likely to be the ones who are fortunate enough to press the Go button on the first downbeat of the biggest shows around. And if there's one thing that never changes, it's that pressing that button will always make the hair on the back of your neck stand up.

projections are used as a way of saving money on scenery or to avoid making intentional decisions ahead of time. As more and more talented media designers come into the industry, though, projections and digital content are fulfilling their unique potential within the live performance design aesthetic rather than being a substitute for something that isn't there.

For lighting designers, projections can offer fresh opportunities for collaboration but also a host of headaches. Producers will often try to saddle the lighting designer with projections in order to avoid paying for another designer. The projector is really just a light, right? Certainly exciting compositions can be made by using projections as light sources, but most projections are meant to be looked at, rather than to reveal the space or objects in the way that light does. Content can be time-consuming and expensive to put together so it is not always possible for a designer to wear both hats. The infinite possibilities created by deciding to have media content in a show can make it hard to arrive at a cohesive design. If neither the scenic designer or the lighting designer have the knowledge or have been contracted to do projections, then a qualified projections designer should be hired, preferably someone who has training in live entertainment design. Aspiring lighting designers can strengthen their employment prospects by learning to design projections and so I would encourage you to learn as much as you can. Keep in mind that just as you have the ability to both enhance or damage a scenic or costume designer's creation with lighting, a projection designer can easily support or wreak havoc on yours.

So what is this conflict all about? From a technical perspective, designed light in the environment and light from the projectors tend to compete with one another. Light in the environment, especially if it is angled such that it lands on or bounces onto the projection surfaces, can wash out the projections. If the lighting designer hasn't thought things through, very often they are forced to light more dimly than intended. In a conflict, projections tend to get favored over lighting, probably because they usually take up a greater part of our field of view. Even if you have no intention of designing projections, the more you understand about them, the better prepared you'll be to collaborate successfully.

From a design perspective, consistency between projections and lighting is necessary to avoid compositions that don't quite make sense. The color, direction of highlight and shadow, and the general brightness should usually be consistent from the lit environment through the projected environment. Multimedia content can be changed more quickly than most conventional light plots so if the designers aren't on the same page they can easily be working at cross purposes.

An example of where this has gone awry for me was a production in which I set up my plot to illuminate the stage environment (a beach with palm trees) in a way that mimicked the sunlight in the projected images that the scenic designer had selected. At one point during tech rehearsals, the director bumped into an image he liked better, and had the projections operator replace the one we had been working with this new one. Though this kind of thing does happen with painted scenery, it never happens that fast because of the time and expense associated with re-painting scenery. In the new image, the sun was coming from the opposite direction and the light in general had a different color quality. This meant that my highlights and shadows were going in the opposite direction and the colors were not consistent between the three-dimensional environment onstage and the two-dimensional background. The director was convinced that it mattered more that the background image was "right" than that the lighting onstage matched it, so I had to adapt.

In environments where labor and time on stage is expensive, such derailments can be costly. If they are *too* costly, the lighting designer may be left looking like they were the one who didn't know what they were doing. Collaboration is key.

Atmospheric Effects

Remember that light has to reflect off something solid in order for us to see it. In Figure 4.30, those beams in the air are only visible because there is *haze* in the air, deliberately put into the space to reveal them. *Hazers,*

Figure 4.30 Atmospheric effects reveal the light in Noah Dettman's design for "Surface" for the University of Arizona's Advanced Lighting Design class

Photo courtesy of Cy Barlow

foggers, rain curtains and other atmospheric effects devices can bring attention to light in a way that makes light the subject. This is an aesthetic choice that must be made carefully as it will pull attention from anything else on stage. Revealing the beams often draws your attention to the source, rather than to what is being lit. That's OK as long as that's the intention.

There are many options for atmospheric effects. Designers have to consider how dense they want the particulate, how long (or not) they want it to hang in the air, how much control they have over air flow in the space, etc. Producers must consider the health and safety of actors, crew, and audience when deciding to use it. Actors' Equity Association (the professional actor's union) can be a good resource for best practices as it helps set safety standards for its members. Be sure to communicate early in the process if you want to use atmospheric effects to ensure that your artistic collaborators are onboard with this aesthetic choice and that your technical collaborators are able to ensure proper protocols.

Take a Breath: The Big Bites Reflections

Let's have another mini-break to absorb the Advanced Lighting Brushes big bites. When you feel settled, read each reflection question one at a time, then close your eyes for another breath or two to notice what surfaces. Jot some notes and, when you're ready, move to the next prompt.

- Advanced lighting brushes: moving lights, LED fixtures, color changers, accessories, LED panels, projection, digital content, VR, AR, xR, HCI, atmospheric effects
 - What are the things to consider when using each of these advanced tools?
 - What kinds of advanced technology excite your imagination the most?
 - How will you take this new knowledge into your next design?

Controlling It All: The Evolution of Lighting Control

Someday when you're scrolling mindlessly, take some time to geek out on the websites of Dr. Eric Trumbull (Introduction to Theatre: A History of Stage Lighting) and Bill Williams (A History of Light and Lighting). I think it'll be a surprise to you how far back in history we can trace ideas about controlling light for artistic reasons. As far back as 1638, architect Nicola Sabbatini suggested dimming light in the theatre by using pulleys to raise and lower metal cylinders over candles. It may be an unusual

place to start, but understanding what was solved and when will help make sense of the technologies as they increase in complexity.

Dimmers

Fast forwarding three centuries after Sabbatini's clever cylinder pulley system, we arrive at electric dimming technology. A *dimmer* is a device that controls the intensity or brightness of a light source. Until recently, *dimmers* were primarily in the realm of live entertainment. Film and television originally needed strong illumination levels for both visibility and color accuracy, so they avoided them. Architectural lighting usually doesn't change much moment to moment, so they didn't have much need for them either. All of this is changing, but imagine what live entertainment experiences would be like if the lights could only be on or off.

It didn't take long after electric light was invented for people to start trying to dim it and the first effective technology was the *saltwater dimmer*. If you recall our electricity discussion, you might wonder if that was such a good idea. It probably wasn't and it was replaced soon after with the *resistance dimmer* and later the *autotransformer dimmer*. But it wasn't until the 1970s that we got where we are now, the SCR or *silicon-controlled rectifier* dimmer.

Saltwater, resistance, and autotransformer dimmers all dimmed lights by mechanical means, which meant that an operator had to physically move handles *at* the dimmer. Electronic technology and the SCR changed all that. Rather than driving or stepping down the voltage, the SCR works by rapidly switching it on and off which affects how bright we perceive the light to be. The most industry-changing advantage of this electronic technology is that dimming could be achieved through an electronic signal command rather than a mechanical lever so dimming and control could be separated. The SCR dimmer is also considerably smaller, which meant that way more dimmers could fit into a much smaller container. This new technology opened the door to amazing functionality that continues to evolve today.

Control Boards and Consoles

Once we could separate dimming and control effectively, the lighting *console* (also known as the *board* or the *desk*) technology race was on.

Let's pause here to address the common beginning lighting student question: "Circuit, Dimmer, Channel, Group, Submaster. . . what does it all mean and why do we need so many numbers?" By now you may be bumping into these terms in your work and an explanation will provide a good contextual understanding of why light boards work the way they do.

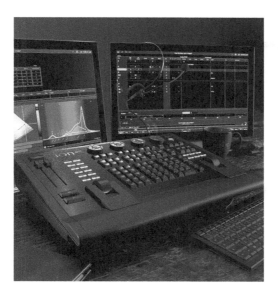

Figure 4.31 An ETC lighting control console

Courtesy of ETC

The *circuit* number is the number on the physical outlet that you plug the light into. It isn't that different than an outlet in your house, if the outlet in your house had a label on it that corresponded to a number on a breaker in your breaker panel. It's a number that's given by the electrical engineer who specified those circuits.

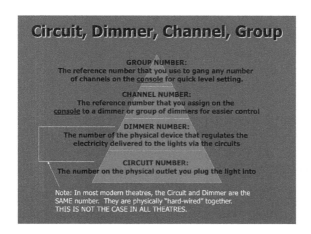

Figure 4.32 Circuit, dimmer, channel, group pyramid

Figure 4.33 Stage pin and locking connector circuit boxes
Courtesy of ETC

The *dimmer* number refers to a physical device that changes the intensity of the light. It might be the same number as the circuit, but it doesn't have to be. In the early days of dimming technology, dimmers were much more expensive than circuits, so it was often the case that a venue would have many more circuits than dimmers. In such a configuration, a *hard patch panel* allows the user to connect different circuits to any dimmer. Patch panels aren't seen much today, having long since been replaced with *dimmer per circuit* systems in which each circuit is hard wired to its own dimmer.

Things would be much simpler for technicians if we left it at that – that is, if we as designers would just call up a light by its circuit or dimmer number. But these numbers have no relationship to what the lights plugged into them are going to do for a particular production. For that we create another layer of numbers that are organized around the design, which we call a *channel* or *control channel*. Channels are virtual and held only in the control console programming.

As plots get bigger, another layer of numbering helps speed things up even more, *groups*. Groups are collections of channels, also virtual, that the lighting designer can use to call up many channels all at one time. *Submasters* too are collections of channels and have been around longer than groups, but I think it's easier to understand them in reverse order. Submasters correspond to physical sliders, often called *faders*, on the light board. They relate back to the earliest light boards when each channel had a physical fader, so you needed another set of faders if you want to

The Wind Down

Color

What is color? To answer that, we have to ask: what even is light, for that matter? Color and light are technically a specific kind of electromagnetic wave, which are moving around us all the time. In Figure 4.36, we can observe that

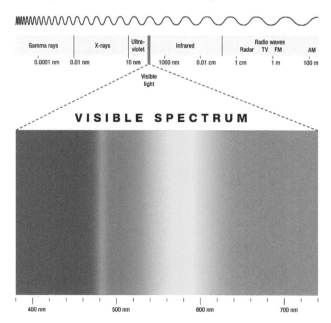

Figure 4.36 The electromagnetic spectrum and the visible spectrum

DOI: 10.4324/9781003022725-8

at certain frequencies, we can use them to see through things, as in an X-ray. At other frequencies, we can use them to heat things, as in a microwave. We can use them to send video and sound, as in over-the-air broadcast. Within that vast spectrum there is this small sliver of waves that we can actually see. This is what light is and more importantly what color is. The frequency of the waves reflecting into our eyes dictate what colors we perceive.

Where is white? You may remember from your science high school class what happens when you put a prism in a beam of white light. It splits into colors. The reason there is no "white" light in the spectrum is that we only perceive white when the whole spectrum of frequencies is present. We see color when the spectrum is filtered in some way.

So then, technically speaking, color represents our ability to perceive wavelengths, but I think lighting designer Stan Pressner said it best, that color perception is a combination of "physiology, psychology and voo-doo". This is a great way to capture the truth about color perception as part science, part individual experience, and part mystery.

Let's say we have a full spectrum light source, which just means it appears to emit all frequencies in the electromagnetic spectrum of color. In this case, the sun perhaps. Let's say it hits a red object. Provided our eyes have full color sensitivity, the red object reflects all wavelength frequencies in the red range of the electromagnetic spectrum, but absorbs everything that is not red. It absorbs the blue, green, yellow, and orange parts of the spectrum, so we do not see those colors, but we see the red that is reflected.

This is why objects that have color like, say, your t-shirt in the middle of the summer, get hot when the sun hits it, but things that are white stay cooler. The color of the object is literally absorbing electromagnetic color waves and being warmed by it.

Figure 4.37 White light becomes color through a prism

© miladrumeva – stock.adobe.com

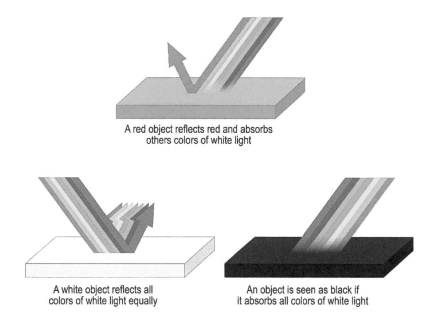

A red object reflects red and absorbs others colors of white light

A white object reflects all colors of white light equally

An object is seen as black if it absorbs all colors of white light

Figure 4.38 Absorption and reflection of color in light

© designua – stock.adobe.com

This is an important thing for lighting designers to understand because when we put a *color filter* – or what is usually called a *gel* into a light – we're not so much changing the color of the light as we are filtering out what we don't want. There will be less light on the other side of the filter than what we started with. It's also part of the reason that gel fades, or even burns through in really *saturated* colors. The more color they have, the more the filter will heat and eventually the color fades. This is part of the reason architectural lighting uses glass color filters – they stand up to the heat longer. Light sources that don't utilize color filters like LED sources don't use color filters or subtract any light, but rather add it.

That color filters subtract light is the reason that putting more saturated color filters on a light source doesn't necessarily mean you'll get more perceptible color. Because we tend to see less color in dimmer light, piling more gel can actually work against you. The way to get more color – particularly when it is a saturated color – is to add more lighting instruments with that color.

Primary and Secondary Colors of Light
If you are studying to be a scene designer or painter, you may know that the primary colors are red, yellow, and blue. When we mix red, yellow, and blue paint together, we get black (or really mud, as any experienced

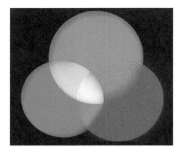

Figure 4.39 Primary and secondary colors of light illustration

painter knows). You can now guess that this is happening because if the mixed pigment contains all colors, it will absorb all wavelengths and there isn't much left to be reflected back to our eye.

Figure 4.39 shows you three colors of light overlapping, which mix to white in the center. What do you notice about those three colors? They're not red, yellow, and blue. Color isn't an exact science and so changing the medium changes the rules.

The primary colors of light are red, *green*, and blue (not red, yellow, and blue as in paint), which you can remember by using an acronym we may hear all the time when talking about video devices: *RGB*. Secondaries are what the primaries make when they mix together in pairs: cyan, magenta, and yellow (in light), which we'll memorize as CMY. CMY is a term you'll hear in all kinds of lighting equipment color mixing contexts later, because incandescent and discharge moving lights usually mix with secondaries rather than primaries. LEDs usually mix in primaries, but the best ones will add other colors to fill in the spectrum (to make them "smell right").

If I were to put these three primary color filters in the SAME light rather than three overlapping lights in the photograph, what will I get? Mud, of course. A bit of dim, colorless light may escape through the three gels and reflect off things that bright, but because I will have absorbed (subtracted) all of the visible wavelengths before the light leaves the instrument, there isn't really much left to illuminate anything.

In this photograph (as in pigment color wheels), the primaries and secondaries are across from each other and also mix to white. We call these combinations (ones that additively mix to white) *complements*. Remember in the first History Break, Stanley McCandless used complements set 45 degrees apart and on separate dimmers in order to mix to white, but get complementary shadows.

Complements

Let's say I have two lights and I know that I want one of them to be green, because there will be times in the show when I want to use just

green, but I also want to be able to mix that green to white. What color would the other light have to be? If you said magenta, you are right. You choose the color on the other side of the primary and secondary wheel. Green and magenta is an unusual combination of colors to use, but one very common combination in lighting is blue and amber. Amber is close to yellow and so when we mix them together we get something close to white.

Getting the Blue Dress Blue

If I want a blue dress to be as blue as it can be, what color gel would I want to put in a single light that lights it? It might sound like a trick question, but it's not. The answer is blue. But why is it that the blue dress will look bluer if I put a blue gel on it than if I put white light on it? It's because when you put that blue gel in, the blue gel filters all colors except blue so only the blue in the dress is reflected to the eye. If the light is white, all colors in that fabric will be reflected to the eye, so it won't seem as blue. Perhaps if the pigment in the threads used to make the blue dress blue were purely blue, it might not matter, but as any experienced costume designer knows, pigment color is rarely that pure. This is also why color consistency in fabric matters. Costume designers are often shocked when items of black fabric from different batches are put onstage next to each other and don't match under bright light.

Consider another common real-life case concerning a blue dress. Often in period pieces, designers like use amber light because it gives it what some of us think is a "period" feel or a feeling that it has happened in the past. What happens then when the costume designer puts the leading character in a blue dress? If you don't know that's what they're planning, then disaster. Luckily for us, the solution isn't difficult and won't impact your design that much. The truth is that even a little blue light in the scene can restore the color of the dress without turning the scene blue. See Figures 4.40, 4.41, and 4.42.

Lighting Skin and Skin Tones

All the same ideas of lighting surfaces apply to skin. Skin, however, absorbs light more and in a less predictable way than inanimate surfaces. Light reflects off the pigment in skin in the same way as it does the pigment on an inanimate object, but skin pigment is much more varied from person to person than is apparent under natural light. It can also take more effort to know the cast's skin than it does to know the color of the set and costumes. Whenever possible, meet your cast

Figures 4.40, 4.41, and 4.42 Getting the blue dress blue when your scene is warm. The first image is lit with unfiltered "No Color" light from two lights 45 degrees off center in each direction. The second image has warm filters in each light, one pink and one amber. The third image adds a blue light at a low level at an angle directly in front of the subject. Pictured: Shannon Wallace

up close during your design process and do color tests when considering uncertain choices. If you are not in the same location, ask for pictures.

As you will read in the perspective of lighting student Amara McNeil in Chapter 7, our industry has neglected to spend time teaching students how to skillfully light performers of color. You must take the time to learn how to light the entire range of skin colors well and if you are a teacher demonstrating color on skin in a lab, be sure to get models of many skin tones. The permeable quality of skin means that it absorbs more than solid, inanimate

Figure 4.43 Lighting a black performer in a white costume effectively. Shown: Vaune Suitt
Photo by Tim Fuller

surfaces. Dark surfaces absorb more light than they reflect and likewise darker skin absorbs more light than lighter skin. For these reasons, special care must be taken for BIPOC performers to ensure that there is enough light to see facial features. Backlight may be more critical than for white performers, in order to ensure good depth separation from the background. It is especially true that when black performers are in light-colored costumes, angles may need to be chosen that maximize light on the face and minimize it on their costume. See an example of this in Figure 4.43.

In general, color filters with pink tint reflect in a flattering way off a wide range of skin tones, so that can be a pretty safe choice if you don't have much time to work with the performers. Light with green or excessively yellow tints will usually make white and black skin look sickly. Amber is the exception, which does have green in it, but usually more red than green and so can be flattering when used skillfully. Some amber color filters can turn light skin orange and dark skin red at low levels, so use caution if what you are lighting is likely to be dim or low contrast (known as *low key* in film).

Saturated colors are less predictable, so skin tests are a good idea if you know you will be using them. I tend to avoid putting saturated colors directly on the face for this reason, but if you have time in the schedule to do tests, you can get some beautiful results. Because color is less apparent on darker objects, well-chosen saturated colors can still feel natural while creating striking moods on BIPOC performers. For a study of bold color choices for dark skin tones, I recommend the film *Queen and Slim* and the television shows *Insecure*, *Dear White People*, and *Empire*. The particular brilliance of cinematographer Ava Berkofsky's lighting of black performers on *Insecure* is the subject of several online articles and videos; do a web search for "Lighting HBO's Insecure". See Figures 4.44, 4.45, 4.46, and 4.47 for some good examples of both dramatic and natural lighting of BIPOC performers.

Figures 4.44, 4.45, 4.46, and 4.47 Recent film and television examples of lighting BIPOC performers. *Dear White People* (Netflix); *Empire* (FOX); *The Mindy Project* (Hulu); *Fast Color* (2018). Shown: Logan Browning; Terrence Howard, Taraji P. Henson; Mindy Kaling; Gugu Mbatha-Raw

© Netflix; Fox Network/Photofest © Fox Network; Hulu/Photofest © Hulu; © Lionsgate/ Codeblack Films

Figures 4.44, 4.45, 4.46, and 4.47 (Continued)

Opponent-Processing Color Theory and Bleaching

Stare at that black dot on this oddly colored flag and don't look away for one minute. After one minute, move your gaze quickly to the black dot in the white space. What did you see? Did you see an echo of the regularly colored American flag in the white space? For some reason we don't fully understand, the mind tries to white balance each of these colors and it was

Figures 4.48 and 4.49 Flag demonstration of opponent-processing color perception theory

© moonrun – stock.adobe.com (colors reversed)

doing that by way of inserting an opposite. These aren't complements as we defined earlier, but another set of pairs specific to opponent-processing theory. For green, it was putting in red. For yellow it was putting in blue. For black it was putting in white. And it was doing it so aggressively that you still saw those colors even when no color was in front of you.

Related to this is the concept of *bleaching*. After the eye has taken in a color for a long time, the color sensing cells in the eye become fatigued

and no longer respond to it. When I was in graduate school for lighting, we would sit at the tech table in the theatre for eight hours a day for four consecutive days with the director and go through the cues, painstakingly adjusting a little here and a little there. The problem was that when we got into the tech rehearsal each night, none of the color looked like what we thought it looked like before our dinner break. This is one of the many reasons not to get too "precious" with your cuing. Sometimes people who don't understand how the process works will want you to get it perfect the first time they see it or want to keep stopping to adjust, but this is usually a fool's errand. The effective and professional way to set levels is in broad strokes which you refine quickly over the course of the technical rehearsal period. This does not mean that you are designing on the fly, it just means that you get it as close as you can before you can see it and then take time to carve in what you intended, like a sculptor. And be sure to take your breaks so you know what you're really looking at.

The Spectral Energy Distribution Curve or SED

Most color filter information and sometimes LED fixture specifications use a graph called Spectral Energy Distribution curve or SED. The graph shows the same range as the Visible Spectrum in Figure 4.36 with a curved line on it specific to that color filter or device. The line tells you what colors of the spectrum are allowed to pass (the high parts of the curve) and what colors are absorbed (the low parts). Another important piece of information somewhere in those color filter specifications is a transmission percentage. This is its percentage of light transmission after the filter has absorbed some of the wavelengths. A filter with a 40% transmission specification is going to let only 40% of the light to pass through. So this gel is going to make the light 60% dimmer than before you put it in. This is crucial to know about.

Here is a real-life example of how transmission might come into play. In my design for *Hands on a Hardbody*, a show about a competition to win a truck, we designed it so that the audience would be on three sides so they would feel like spectators at the competition. For lighting to support that, I wanted to be able to light the entire performance environment (including the audience) the same. In other words, instead of having the audience completely dark, as in most theatrical situations, I wanted to have color continuity from the performing area through the audience area. For the night scenes I wanted a deep almost ultraviolet blue and so I chose a color filter which has a 0.3% transmission. It filtered 99.7% of the light out. Because of that low transmission, I had to put that gel in 38 lights around the room to ensure that I had enough light for the deep color to read across the entire space. I could have chosen a less saturated color and would have needed fewer lights, but it wouldn't have had that same feel. How did I

know I needed 38 lights exactly? I didn't. That was about how many lights I decided I could afford from my inventory for the effect and then I had to do tests to know if the color I wanted to use would give me the result I wanted.

LEDs and Color

LED fixtures mix color additively within the light, as opposed to when you put a filter in a fixture and take light away. When LEDs came onto the scene, it changed how we deal with color for many reasons. In many ways it got easier, because now you don't have to predict how gels will mix and you can change color instantly without ever leaving the light board. The downside is that you have to be willing to spend money to get good color fidelity. Each LED color emits a narrow part of the color spectrum, so in order to get the full range of color, a fixture needs a variety of diodes. The more colors of diodes in the fixture, the better range of colors you are likely to be able to get.

CIE Chart of Photosensitivity

Because of our eyes' variable color sensitivity across the spectrum, the traditional color wheel is inadequate to illustrate the multitude of colors of reflected light that we can see. Scientists created a horseshoe shaped map called the *CIE Chart of Photosensitivity* to better demonstrate this. You may notice right away that there are more greens and yellows available to us than there are blues and reds.

Figure 4.50 The CIE Chart of Photosensitivity

© Peter Hermes Furian – stock.adobe.com

One of the things that is fun about this chart is you can actually plot your color choices on it. It's a little tedious, but it'll tell you some things about the range of color available when mixing your selections. Of course there are computer programs that can simulate this as well.

The technical aspects of color that we have spent time exploring in this chapter are more about getting yourself out of trouble than they are about actually making artistic choices, which you'll do with your heart. In the next History Break, I'll share with you my story of how some pros impacted my use of color as a designer.

History Break: Masters of Color

This History Break is a bit different in that these folks made their ways on to the scene much later in the lighting history timeline than most of our other subjects and they are all still busy making their marks. I call your attention to them because of the impact they had on me and others by publicly teaching about their experiences with color in light. In 1998, designer Jules Fisher asked his friend Beverly Emmons to develop a Color Lecture for Broadway Lighting Master Classes. She teamed up with designer Clifton Taylor to develop it and, for that first one, designer Stan Pressner joined them. Beverly and Clifton each went on to do lectures and demonstrations about color in light at conferences over the years and I went to them anytime I had the opportunity. Here are some of the insights I took away, along with some reasons you should hear them speak if you ever have a chance. These are notes I scribbled many years ago and then incorporated into my lectures, so it is impossible to know if I am quoting them directly or paraphrasing. I attempt to honor the spirit of teachings as faithfully as I can.

Beverly Emmons found lighting design through her studies in dance. She has lit just about every genre of live performance including 22 Broadway shows. She holds the distinction of being asked to re-light the entire Martha Graham Dance Company repertoire, which for four decades previously had been lit by Jean Rosenthal (from our Chapter 2 History Break). You can read about her experiences and see some of the plots and paperwork from this work on thelightingarchive.org and performingartslegacy.org.

Emmons struck me as a master of subtle color and spoke about using color contrast with pale colors to evoke emotion, particularly if you have a small inventory. In a takeaway that has affected every dance collaboration I have ever had since then, Emmons said that when working with choreographers,

you'll glean much more from what they create than what they say. Spend time with them while they're creating if you can, and usually your work will emerge organically along with theirs.

I saw Stan Pressner speak about color only that one time at BLMC, but now I see him every year giving artistic and career advice to young designers at conference portfolio reviews. He too has designed for just about every genre, including television, and is currently as busy as ever.

Stan is the source of one of my favorite quotes mentioned earlier, that color mixing is "a combination of psychology, physiology, and voodoo" and he told me recently that that list should include "physics". He talked about taking some of the mystery out of it by plotting your choices on the CIE chart to see if you have the mixing potential you think you have, something he learned from designers Tom Skelton and Craig Miller. In a recent exchange, he emphasized that "all color is relative, in three ways: personal physiology, cultural referents, and assigned meanings".

I saved Clifton Taylor for last because he permanently etched his place in history just recently with his exceptional book: *Color and Light: Navigating Color Mixing in the Midst of an LED Revolution, A Handbook for Lighting Designers* (2019). Please add it to your reading list as soon as you can. *Color and Light* is the culmination not just of his years of experience as a designer, but his years of lecturing about it and refining how to demonstrate the concepts. You can view several of these demonstrations on the book's website and learn how to set some up for yourself.

The most revelatory takeaways for me from Taylor were about color *hierarchy* and contrast. It was through him that I learned that yellow-green is generally the most dominant color, even more so than clear or no color. This is to say that yellow-green cannot be affected very much through mixing – it will always stay apparent, no matter what color you try to mix in with it. He suggests that you put the more dominant colors of your design in the backlight for that reason. In terms of color contrast, he notes that blue backgrounds will make foreground objects seem warmer and that red backgrounds will disable your ability to light the foreground warm, because you will never be able to compete with the warmth of red.

Color in light is a topic that will keep you learning for the rest of your career. Be sure to get yourself in the room with these masters of color if you ever have the opportunity!

Figure 4.51 Four Quartets, a full evening dance theater work by Pam Tanowitz based on the poem by T.S. Eliot; music by Kaija Saariaho; scenic images based on paintings by Brice Marden; scenery and lighting design by Clifton Taylor; costumes by Reid and Harriet; sound design by Jean-Baptiste Barrière

Photo by Clifton Taylor of the premiere production at Bard /Fisher Center for the Performing Arts

Take a Breath: Reflections and Trailheads

As we close on Chapter 4, I invite you once again to pause and allow it all to take root in your mind. Since we took breaks throughout Parts 1, 2, and 3, the reflection prompts for those will consist of the topics only – you can decide what you'd like to think about or review. Grab something to make notes with and make yourself comfortable. Close your eyes and bring your attention to your breath for just a few inhales and exhales. When you feel settled, read each reflection question one at a time, then close your eyes for

another breath or two to see what surfaces. Make some notes, and when you're ready move to the next reflection prompt.

Reflections

Part 1: The Basics

The technical standard-bearers
Safety in entertainment
The controllable qualities, properties, or attributes of light; the conventional, established lighting instruments; electricity essentials

Part 2: Pause, Step Back, Absorb, and Reflect

Strategies and thoughts on keeping current

Part 3: The Big Bites

Advanced lighting brushes: moving lights, LED fixtures, color changers, mechanical accessories, LED panels, projection, digital content, VR, AR, HCI, atmospheric effects
Entertainment lighting control: dimmers, control, consoles, control containers, DMX, and the alphabet soup of lighting systems control

Part 4: The Wind Down

- Color
 - What are some things you remember about how we see color?
 - Were there new ideas about color in light that surprised you?
 - How will you handle lighting for less represented skin tones and multiple skin tones in the same composition?
 - What concepts will you take with you into your next design?

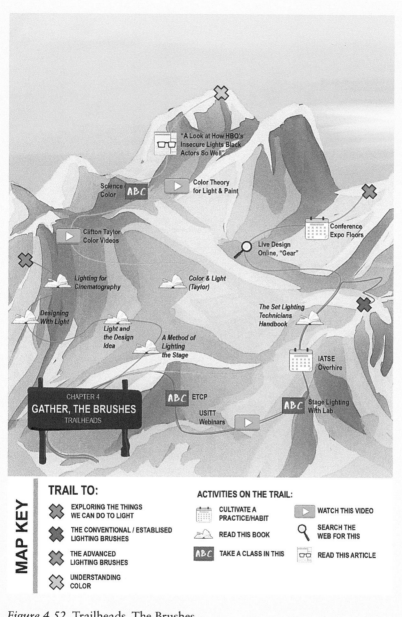

Figure 4.52 Trailheads, The Brushes

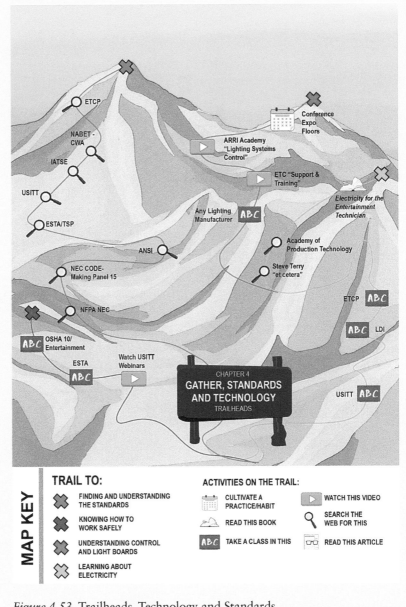

Figure 4.53 Trailheads, Technology and Standards

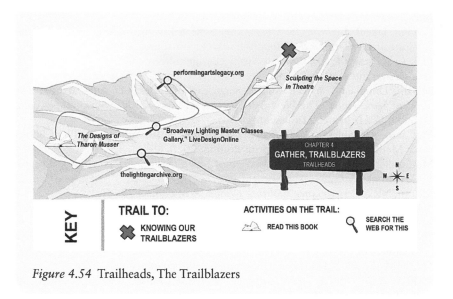

Figure 4.54 Trailheads, The Trailblazers

References and Resources

"About." *Beverly Emmons*, Performing Arts Legacy Project, performingartslegacy.org/emmonsbeverly.

American Cinematographer, ascmag.com.

ANSI, American National Standards Institute, ansi.org.

"ANSI E1.11 – 2008 (R2018)." *USITT DMX512-A Asynchronous Serial Digital Data Transmission Standard for Controlling Lighting Equipment and Accessories*, tsp.esta.org/tsp/documents/docs/ANSI-ESTA_E1-11_2008R2018.pdf.

Bennett, Adam. *Recommended Practice for DMX512: A Guide for Users and Installers: Incorporating USITT DMX512-A and Remote Device Management, RDM*. PLASA, 2008.

Box, Harry C. *Set Lighting Technician's Handbook: Film Lighting Equipment, Practice, and Electrical Distribution*. Routledge, 2020.

Davis, Jeff, Rennagel, Marilyn, and Delbert, Unruh. *The Designs of Tharon Musser*. USITT, 2007.

Essig, Linda. "Stanley McCandless, Lighting History, and Me." *Theatre Topics*, vol. 17, no. 1, 2007, pp. 61–67. doi:10.1353/tt.2007.0008.

ETCP. *The Entertainment Technician Certification Program*, etcp.esta.org.

"Fundamentals of Lighting." *The IES Webstore – The Lighting Authority*, store.ies.org/product-category/education/fundamentals-of-lighting.

Gillette, J. Michael, and Michael McNamara. *Designing with Light: An Introduction to Stage Lighting*. 2020.

"IALD News." *International Association of Lighting Designers*, www.iald.org/News/In-the-News.

IATSE Labor Union, Representing the Technicians, Artisans and Craftpersons in the Entertainment Industry, www.iatse.net.

IES. *Illuminating Engineering Society*, www.ies.org.

InfoComm. www.infocommshow.org/event-info.

Landau, David. *Lighting for Cinematography: A Practical Guide to the Art and Craft of Lighting for the Moving Image.* Bloomsbury, 2019.

LDI. *Live Design International,* www.livedesignonline.com.

Live Design International Show, www.ldishow.com.

Martin, Douglas. "Tharon Musser, Stage Lighting Designer, Dies at 84." *The New York Times,* The New York Times, 21 April 2009, www.nytimes.com/2009/04/21/theater/21musser.html.

McCandless, Stanley Russell. *A Method of Lighting the Stage.* Echo Point Books & Media, LLC; Restored Reprint Edition, 2020.

McCandless, Stanley Russell. *A Method of Lighting the Stage.* New York: Theatre Arts Books, 1932.

Moran, Nick. *Performance Lighting Design.* A & C Black, 2007.

NABET-CWA. *National Association of Broadcast Employees and Technicians,* 24 Nov. 2020, www.nabetcwa.org.

"NAB Events." *National Association of Broadcasters,* www.nab.org/events/default.asp.

"NAMM Show." *NAMM.org,* www.namm.org/thenammshow/2022.

"NFPA 70®." *NFPA 70®: National Electrical Code®,* www.nfpa.org/codes-and-standards/all-codes-and-standards/list-of-codes-and-standards/detail?code=70.

PLASA Media Inc – Lighting & Sound America. *L&S America Online,* www.lightingandsoundamerica.com.

Plasa Show, www.plasashow.com.

PLSN. *Projection Lights & Staging News.* plsn.com.

PR/Agency User Jun 14, 2021 7:11am, et al. "Broadway Lighting Master Classes Gallery." *LiveDesignOnline,* www.livedesignonline.com/special-report/broadway-lighting-master-classes-gallery.

Prolight Sound – The Global Entertainment Technology Show, pls.messefrankfurt.com/Frankfurt/en.html.

Protocol. *ESTA.* www.esta.org/Protocol/protocol.html.

Taylor, Clifton. *Color & Light: Navigating Color Mixing in the Midst of an LED Revolution, a Handbook for Lighting Designers.* Quite Specific Media, a Division of Silman-James Press, 2019.

"TEA News." www.teaconnect.org/News/TEA-News/index.cfm.

"The Lighting Archive." *The Lighting Archive,* thelightingarchive.org.

"Theatre Design & Technology." *United States Institute for Theatre Technology,* www.usitt.org/tdt.

Trumbull, Eric. "A History of Stage Lighting." *Introduction to Theatre: A History of Stage Lighting,* novaonline.nvcc.edu/eli/spd130et/histlighting.htm.

TSP. Technical Standards Program. tsp.esta.org/tsp/index.html.

USITT. *The United States Institute of Theatre Technology,* Inc. www.usitt.org.

Williams, Bill. "A History of Light and Lighting." LightingAssociates.org, www.lightingassociates.org/i/u/2127806/f/tech_sheets/a_history_of_light_and_lighting.pdf.

Choose

After gathering a full plate of concepts and resources, you may be wondering how to put it all together. Chapter 5 explores processes that lead us to choosing.

Approaching the Design

If design is defined by intention, how does the designer find an intention?

It is rare for a lighting designer to start with a blank canvas. We usually begin with a story, music, theme, idea, or message as a starting point. How defined the path is from that starting point will vary with the activity you're working on, the people footing the bill, and the people you are working with. If there is a director or creator, much of the path may be defined by them.

A script analysis or dramatic structure class is required for many college theatre and sometimes film majors. If this isn't your experience, I recommend seeking one out, no matter what field you're planning to go into, because it will make you a better designer and collaborator, and provide you with a richer experience in your work. Designers who lack skill in dramatic analysis may neglect to support deeper story objectives and subtext because they don't know it's there.

For text-based work, script analysis begins, of course, with a reading of the text. If time allows, I do a quick first read without thinking too much about what I'm going to do with it and then put it down for a while. Often the story will play in my subconscious and things will come up organically that make me want to know more. On the second read, I make notes about impressions and ideas, and organize any questions I have about the writer's intentions or story progression. I make note of

requirements related to the Given Circumstances (as discussed in Chapter 3). By then, taking a third read will get the idea engine going.

A nuts and bolts analysis usually happens during the second or third reading. This might be a *scene breakdown* for text-based work, or a *moment-to-moment breakdown* for non-text-based work, or a *song* or *music changes breakdown* for music-driven work, or some combination of any of these. I like to organize scene breakdowns in a database-style document in which I can add columns when I come to realize that a particular work has a unique question to be pondered throughout. For example, when designing the play *Reckless* by Craig Lucas, I knew that I wanted the lighting in each scene to echo or contrast the main character's state of mind. She is on the run, coping with the trauma of an absurd string of challenges completely out of her control. In the script breakdown for that play, but not any other play, I added a column titled "Rachel's State of Mind". I made notes as I went through the script and it ensured that it influenced every decision I made.

When there is no starting text, as is often the case in dance, architectural situations, experiential settings, or new work information has to be gathered from the people generating the creation. As I mentioned in the last History Break, when working with creators in movement-based fields,

Figure 5.1 Lighting scene breakdowns

I find that it's better to watch what they are doing rather than have them talk about it. That isn't always possible if you aren't in the same town, or if you do a lot of different projects to make your living, but time spent watching the work being made will inform you in ways that nothing else can. A trust and a special connection develop. It is completely possible to light something after being presented only the finished product and that can be the norm, but it's a missed opportunity to be a part of the "mutually conceived artistic whole", as Jean Rosenthal's biographers put it. If you can't be, or if there's no work being made to watch, be sure to ask questions that draw out the heart of the creation like "what does this work mean to you?" rather than surface questions like "what do you think this should look like?" It takes longer that way, but it'll generate a better design.

If music is part of what is being created, the designer should try to let that music get into their soul. Listen to it over and over again until you hear it in your sleep. Designers who have their own personal relationship with music – especially those who play an instrument – will see visual images and events begin to take shape when they listen to the music. In every field, music changes will often cue lighting changes. That doesn't mean that lights *should* change every time there's a music change, but that every music change is an opportunity to consider a lighting change. After you've been around lighting for music for a while, you will feel it when a music change demands a lighting action. Be sure your other collaborators are on the same page as you, though. It is not uncommon to sense a big music moment in your analysis that is interpreted differently by a choreographer or musical director.

Two good questions to ponder in anything you are designing are: "Why will the audience stay until the end?" and "What can lighting do to support the story, theme, goals, or intentions?" The first one will get at what the story or message is really about, revealing the destination. The second defines the designer's role and responsibility in the experience being created. More granular decisions can be explored by continuing with the questions in the "Objectives (or Functions or Uses or Impacts) and Properties (or Qualities or Attributes) Analysis" we discussed in Chapter 4. These would include questions about how much Illumination and where audience attention should be directed; how much does lighting need to support the Given Circumstances; what is the Mood and what Color and Angles does it call for; what are the Rhythms of the piece and how much will the lighting Change or Move to match (or contrast) those Rhythms? Those questions will not be answered all at once, nor should they be set in stone when they *are* answered, but it's a good idea to begin tugging on those threads early in the process.

Once the designer has a good grip on the story, themes, and/or messages of the work, *contextual* and *visual reference research* follows. I introduced this in Chapter 2 when I asked you to consider how to be more informed than influenced. As I said then, contextual reference research

is an intellectual exercise. We look for information about the author, the period, locations, reviews and writings about past productions, and scholarly analysis of the text or literature. Most of this can happen through web browsing and your library databases. I encourage the collection of a "gluttony of information", because most of it will be discarded, but all of it will inform your process. It's kind of like taking pictures, you have to take many to get a few good ones. Keep what you find in a show folder or bookmark them in your browser. There may be a moment in your process when you realize the value in something you didn't the first time and you want to find it again. This part of the process may also include collecting drawings and other relevant materials from the rest of the creative and production team or other stakeholders. In architecture, this is most closely related to the *programming phase*, as described in both the *Fundamentals of Lighting Handbook* and *Fundamentals of Lighting* book by Susan Winchip. This is an especially critical phase in architectural design where not having detail can be costly.

Visual reference research contributes to multiple parts of the process. Abstract images with color, texture, and tone influence the emotive quality of a design as well as assist in the later choices around color palette and angle/direction of light. Pictures inform practical questions like how light from a campfire illuminates the area around it, what light reflected off water looks like, or how we can see things at night or in the dark. Fine artwork such as paintings, graphic art, and photography inspire choices about how light can be effectively utilized for different dramatic situations,

Figure 5.2 Sample collages

Courtesy of Tori Mays, Noah Dettman, and Megan Mahoney

locations, and different times of the day or year. As you do visual research on the Given Circumstances, keep an eye out for situations where a writer may have had light in mind when setting their story because it can deepen your understanding of that source material. Consider the information in these titles: *A Long Day's Journey Into Night. . . Wait Until Dark. . . The Light in the Piazza. . . A Midsummer Night's Dream.* This doesn't mean that we are obligated to design it the way the source creator imagined, but we should be sure that diverging doesn't work against us.

All of this research assists the designer in better *communicating their ideas.* As with anything, you have to consider who you are talking to and whether or not your references will inform them in the same way that it informs you. Contextual references make for good conversation but a scene breakdown, for instance, may not make sense to other collaborators. Visual images are often shared amongst collaborators, especially the other designers. One of the most tried and true designer communication tools is an *inspiration board* or *collage* of visual references. This tool can communicate both abstract ideas such as color, texture, tone, contrast, and composition, as well as specifics, like how a particular moment might want to look like. When you search for inspiration, I can't emphasize enough that you shouldn't choose the first image you come to. One of the great heartbreaks that the internet has brought design teachers is when students web search something like "Victorian couch" and choose for inspiration the first one that pops up. Good design emerges from curiosity and an exploration of possibility. Ask yourself, why are *these* choices the *best* ones I could make? Don't stop looking until you have a good answer. Even if you come back to the first one, you'll be sure it's the best choice.

History Break: Jennifer Tipton and the "Conceptual Hook-up"

"One of my former students works on Broadway a lot now; he recently lit an August Wilson play with 500 lights . . . If you put a gun to my head, I could not light an August Wilson play with 500 lights," reflected Jennifer Tipton for the 2006 book *Sculpting Space in the Theatre* (p. 140).

This is one of my favorite Jennifer Tipton quotes and it makes me laugh and nod every time I hear it, but if you don't know much about her, it might lead you to some incorrect conclusions. My students read that chapter and wonder what successful lighting designer wouldn't be thrilled to have 500 lights for a design. . .

Figure 5.3 Jennifer Tipton

Courtesy of Jennifer Tipton

Tipton was born in 1937 and started her career as a dancer. She began lighting dance in the 1960s, lit her first show on Broadway in 1969 and won her first Tony in 1977 (IBDB). She has designed at least 40 Broadway shows, hundreds of dance productions, more than a few operas and even created a lighting installation above the Hudson River. She has won numerous awards including the $500,000 MacArthur "Genius Grant" in 2008 and, as recently as December of 2019, the Baryshnikov Arts Center's Cage Cunningham Fellowship. The theme of the Cage Cunningham Fellowship is artistic innovation, and Tipton intends to use the $500,000 award in collaboration "with a set designer and a sound designer to develop an immersive installation centered on the disintegration of the planet's natural resources". Tipton doesn't need 500 lights for an August Wilson play, but it isn't because she doesn't know what to do with a big inventory.

And what about Tipton's student on Broadway? It isn't difficult to figure out who that was, but know that Tipton has many successful former assistants and students. Even though he never studied with her at Yale, she is often regarded as the designer who set Howell Binkley on his path. Binkley was the LD for *Hamilton* and *Jersey Boys*, both of which he won the Tony Award for, and a co-founder of the Parsons Dance company. Donald Holder, who won the Tony for *The Lion King*, is one of Tipton's Yale alumni, as is Robert Wierzel, who has won numerous awards and lit in just about every well-known venue in the country.

Besides having the Cage Cunningham Fellowship to brag about this year, Tipton herself is up for a Tony again, this time for the acclaimed Aaron Sorkin adaptation of Harper Lee's *To Kill a Mockingbird*. This is just two

years after her nomination for the also acclaimed *A Doll's House, Part 2*, an award she lost to her former student Chris Akerlind for *Indecent* and she can commiserate with Don Holder, who was nominated for *Oslo*. That's right, in 2017, of the four nominees for Lighting Design (Play), one was Jennifer Tipton and two were her former students. (See in references, "The Tony Award Nominations".)

One tool from Tipton I borrowed for students is what she called a *conceptual hook-up* (also from *Sculpting the Space*). I call it the *lighting needs inventory* to emphasize that it's a good idea to have a sense of what is necessary before you get too far down the road. It ensures that you have everything necessary, but also that you are versed in how light inherently exists in the work. Tipton describes her conceptual hook-up like this: "a list of what the play needs with respect to light . . . We take our list and look at the space, and then we go back and forth between these two things until finally the list represents what the play needs, in the context of what is possible" (p. 135). The next time you work on a design, start with this exercise and notice how it grounds your process.

I also credit Tipton for causing me to realize that at some point in your studies you should take the time to sit with a single light coming from each possible angle (one at a time) and find out what it evokes for you. Tipton gave a widely attended talk on the mainstage of the 2008 USITT national conference in which she did just that, talking about how she felt about each angle of light. Much of it was what we might think of as basic information like "backlight separates the performer from the background" and "side light reveals dimension" but the exercise of making time to immerse yourself in the feeling of each lighting angle can be inspiring.

Whether Jennifer Tipton earns a Tony in her 80s or not, you can be sure that her influence on our field will go on for a long time. Be sure to connect with her if you have the chance.

Laying Out the Light Plot

When I teach lighting design, whether to beginning or advanced students, no matter how inspired they are or how confident they feel about what they have learned, things usually come to an awkward pause at this point in the process. I hear something along the lines of: I understand how to observe light, I have a grasp on the equipment, I'm inspired by the journey of light as I envision it in the material, but I don't have a clue where to

put the lights. Don't panic! This is perfectly normal. It has to do with the fact that lighting instruments and technical specifications don't look anything like the end experience we imagine creating. Generating technical specifications is a whole skill set in itself. Your ability to complete them competently and professionally is likely to have an impact on getting your career off the ground, but being good at drafting and paperwork isn't the same thing as being a good designer. You *will* have to learn how to do the drafting and the specifications, but don't confuse those tasks with the design. In Appendix 1, I'll point you toward some resources and I strongly recommend an entertainment drafting class, but much of it you will learn assisting others who probably learned it the same way. In the meantime, once gathered, reference research, process, and inspiration bring you to decisions about what you want a scene to look like, and once you know what equipment is available and where you can hang it, then deciding where to put the lights isn't as big a leap as you might think. This next project will help you understand the through-line.

Project: The Mini-Lighting Design

A more detailed version of this project with step-by-step teaching instructions can be found in the *Practical Projects for Teaching Lighting Design* (2016) published by USITT. It is based on what my teacher James H. Gage called "The Photo Project", but there are many similar hands-on picture-to-lab projects out there. This version starts a step earlier, with a scene, giving the experimenter something closer to the true design process.

For the least experienced, this works best as a group project because it puts more brains on the task and gives them a taste of the ups and downs of collaborative creation. So if you're not in a class, grab some friends!

To realize this project fully, a full light lab or scale lab is helpful. A visualizer program is useful for experimenting with possibilities before dealing with ladders and wrenches. There are many visualize options now, ranging from user-friendly to complex. I have always used Virtual Light Lab by West Side Systems because of its relatively cheap cost and its easy learning curve, but there are far newer and more sophisticated options available, like Capture, WYSIWYG, and Augment3D.

In a resource pinch, there are creative ways to do this project without a lab or visualizer. The process is to read a scene, make some decisions about what it should look like, find some visual references from which you can evaluate angle and color, apply choices, work through some other possibilities, and

play. You could do all that with just a scene, a search engine, some clip lights, and some color filters if you had to.

Procedure

Step 1: Pick a scene. I recommend classic Shakespeare scenes like the witches scene from *Macbeth*, the balcony scene from *Romeo and Juliet*, *Othello* in the bedchamber, or the first forest scene from *A Midsummer Night's Dream*. Shakespeare scenes don't always give as much directive so there is more opportunity to think about light as it relates to the spoken words and story. If you're having trouble getting started, try something more prescribed, like a Tennessee Williams piece, but you'll have more fun if you move away from those kinds of heavily described works as you start to get the hang of it.

Step 2: Find reference images. Choose at least three photographs, paintings or images that have a quality of light (in terms of angle, color, composition, contrast, etc.) that *feel* like what you think your scene should feel like. It's OK to use search terms for the mood, location, time of day, and any other Given Circumstances, but avoid using search terms like the title, playwright or characters, because you will end up with production photographs, which just give you someone else's answers.

Step 3: Evaluate the physical circumstances of light in your reference images. If it is available to you, use a visualizer to move lights around and change the colors to come to decisions about where, relative to an object in the center of a space, lighting instruments would be located, and what color each light would, be to create a lighting look inspired by your reference images. Sketch out your decisions in some way that makes sense to you can be referenced and updated when you are moving lights around in real space. If you don't have access to a visualizer, just guess where the light is coming from and draw some arrows on a piece of paper. Such a drawing is called a lighting key or an angle/color concept.

Step 4: Light your scene. In a physical light lab or in your living room with clip lights or some other creative means of arranging light sources around an object, place lights where you think they should go and move them around until you match your inspiration image, or until you run into something you like better. Don't be attached to your original ideas because you might stumble on better ones. You will quickly find that lighting three-dimensional space has challenges that are not apparent in a two-dimensional reference image, and that's OK because that is part of the learning experience of this project. Be sure to play and experiment to get all that you can from each attempt.

Step 5: Reflect on your experience. What did you learn about physical space, light, and color in this particular scene challenge? Show your final image and ask the viewer what they experience. Did it communicate what you meant for it to communicate? Why or why not, and what might you have done differently to communicate more clearly? What did you learn about each step in the process? What adaptations to the process might you make for yourself next time around to get to an even more effective or efficient outcome?

Research 1

Research 2

Figures 5.4, 5.5, 5.6, and 5.7 Sample project submission images.

Student work courtesy of Kendall Phillips, Rachelle Fernandez, Cheryl Thompson, and Rayrn Wintersteen

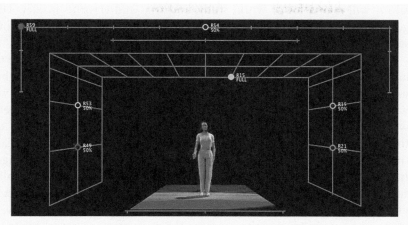

Virtual Image

Final Light Lab Image

Figures 5.4, 5.5, 5.6, and 5.7 (Continued)

Laying Out the Light Plot (Continued)

If you put the Mini-Lighting Design Project together with what you've learned about the different types of lighting instruments, knew what you had and where you could hang them, you could light a scene. You could light several scenes. If you're working in a recorded or virtual medium in which you can move the lights around for each scene, this may be all you need. . . Go design!

Now what happens when it's time to light a whole show in a fixed period of time with a live audience? This is when things get complicated

and it will take a lot of work, study, and trial and error to master. The good news is that there are lots of tips and tricks to guide you in getting started.

In a lighting designer's dream world, we would have enough space to hang equipment specific to each scene, or we would have magical lighting instruments that could make every kind of color and quality that we wanted, or that could fly around the theatre quickly and quietly to where we want them for each scene. Technological advances get us closer to those dreams every day, but in the meantime, the reality of doing live real-time performance presents constraints that we have to creatively manage. It is rare to have a playing space compartmentalized enough, or physically small enough – relative to the amount of space there is to hang lights – in order to have every scene lit with its own set of instruments. Even when you get that lucky, the need for the performers to travel between the acting areas, or full stage moments like the bows, make it necessary to find a means of lighting continuity across the whole performance space. Even just the desire of the director to change their mind when they begin transferring the blocking from the rehearsal space to the performance space means that you usually have to construct your light plot ready for adaptation.

If you do have enough space and equipment, or enough variable equipment to light each scene with lighting instruments specific for that scene, then you should do it that way. This will give you the most interesting, appropriate, effective, and personal design. You could start with a "conceptual hook-up" as Jennifer Tipton describes, perhaps first prioritizing your conceptual list in case you do have to make compromises, or just starting at the beginning of the show and working your way through. Assign lights for each scene until you've placed everything you need.

I'll illustrate with the single-scene project example shown in Figures 5.4–5.7. That group determined that they wanted lights coming from seven angles. They used two front lights, one on center, and one from SR; two side lights from left and right each, one low and one high, and one back light off center to SL. If the scene involves one person standing in one place or in one small area, as in this project, one lighting instrument from each of those angles would work. This may also be true in film or television where large wash fixtures and/or close camera angles are common. From here the team would decide which kind of lights to grab from the available inventory (probably ERS or Fresnels), hang those seven lights, color them, set relative levels, and their design is actualized!

If the space we are lighting is larger than this, however, the plot will need to scale up. Very generally speaking, *acting areas* (or what we often call *focus areas*) on a stage that are more than 8' wide or deep will require more than one light from each angle to ensure coverage across the area.

Some angles require fewer sources than others. For example, the low side light specified in that project will cover considerably more area because it is shooting across the space rather than being pointed at one area. For me, I prefer that what we call *focus points*, the center of the acting area where we stand to focus a light, be no more than 5' or 6' apart. This is particularly important for *front* or *face light*, which is the angle or angles from which the audience is viewing. The reason for that is that unevenness in light is more likely to be noticed when we are looking at a performer's face. Pools of light are brighter in the center and dimmer away from the center, so if you spread your inventory too thin, there can be *dips* in intensity. Since natural light doesn't tend to behave like that, this can be distracting and is usually the mark of a poorly constructed light plot or a sloppy focus.

You might think you can thwart physics by choosing a lighting instrument which projects a bigger pool of light, or by moving the light further away, but remember that all other things being equal (instrument type, wattage, etc.), smaller pools are brighter, bigger pools are dimmer. Relatedly, given the same type of lighting instrument, a light will be brighter if it's closer and dimmer further away, exponentially so. You can cheat physics with a little cleverness, but at some threshold, your design will just look thin and dim.

There's really not a good way to get around the fact that the more area you have to light and the more scenes you have to light, the more lighting instruments you need and the more space you need to hang them. If a production intends to use the entire space for multiple scenes, the ability to light each scene in its own way diminishes.

To illustrate this in an exaggerated way for effect, let's look at Figures 5.4–5.7 as an example again. Let's say that this scene the team wants to have lit from seven angles takes place across the entirety of a 40' wide by 30' deep stage; how many conventional lighting fixtures would have to be hung? I mentioned before that certain angles can cover more area, so you wouldn't necessarily need a low side light for each area – maybe one of those could cover the stage – but in order to look at this example in a worst-case-scenario kind of way, let's pretend that we do.

To keep our focus points no more than 6' apart and light the entire space, we need at least seven focus points across the space times five points deep. That's 35 focus points times seven lights for each focus point, which would be 245 lighting instruments for this one scene. There aren't many scenarios in which we could afford to use 245 lights for any one scene. And if there were, say, ten scenes like this in this show, each one using the whole stage, we'd need 2,450 lights, which is not possible. This is an exaggerated example and most directors don't stage like that, but the challenge will lie somewhere between a tight acting area for each

scene (ideal) and using the whole stage for every scene (a recipe for a disappointing design).

One of the most efficient strategies for reaching a compromise between what you'd like to have and what can physically be accomplished is to work in *systems*. Dance, opera, and festival designers have this technique mastered because they often use a single light plot not just for one show, but sometimes many shows or even a whole summer of shows. When done that way, the plot is considered a *repertory*, or *rep* plot. A system is a series of lights coming from one direction doing the same thing, but each light is focused to its own area. There might be a system of front light, or a system of backlight, or a system of high side light from SL, etc. If there is more than one color of that angle, we'd call it a different system. There might be a high side blue from SL system and a high side pink from SL system. If advanced technology is available, there might be a backlight color changing system plus a backlight neutral system. With a light from each system focused to each area in its own control channel, the designer is able to light one area independently or many areas evenly. With two colors from any given direction, the designer is able to light from that direction in one color, or the other color, or the many options that exist when two colors are blended.

You can understand now how working with systems generates more options with fewer lights, but requires more compromise. For example, maybe you have room for only two systems of high side light from SL. Maybe you want to light one scene from that direction in one kind of blue and another from that same direction with another kind of blue. You'll probably end up compromising by picking a blue that works well for both, otherwise all you'll have in systems from that direction is blue. If you're really clever, maybe one of those scenes only takes place in one area and so you can hang a *special* – a light for just that scene – that has the blue you want, freeing up your system to be the other blue. Clever resource management is key. Color changing fixtures or movers help. The low side lights in the wings often get a manual color change when the curtain comes down between dance pieces for just this reason.

Lighting Teams, Organizational Structures, and Why the Variations

Consider what you know so far about the industries we've surveyed and why differences in organizational structure might exist. Certainly the scale of the production is a big factor. Small independent films may have only a few people producing the entire film, while a mainstream action film may have hundreds of people in the credits. There are many small professional theatre companies in which a single production person is the entire team

(lighting and everything else), but a Vegas spectacular might have dozens on the show crew itself and dozens more on the day crew.

A less obvious reason for the differences are the timelines a discipline works under. For example, the dance lighting designer is often also the programmer and light board operator, and there may not be a technical team at all. When this happens, it is usually because the company uses a fixed light plot and the choreography may continue to evolve even through the run of performances. A similar thing happens in the concert industry in which the lighting designer is often also the programmer and console operator, in part because the set list may not even be decided until right before the performance and because the design is more fluid. In contrast, in traditional theatre, opera, and other fixed location live performance, the lighting designer locks in the design and then moves on to their next project as soon as the show has opened.

For the most consistent organizational structures, we can look to the areas that have union representation, contractors, or any specialists who work under well-defined contractual, legal, or safety protocols. When United Scenic Artists and/or the International Alliance of Theatrical Stage Employees (discussed in Chapters 3 and 4) are involved and the scale is large, you can be bet the job descriptions will be well-defined. Members of the design team are generally not meant to touch equipment in the venue and the procedures around labor are strictly controlled. This includes both Broadway and regional theater rated LORT (League of Regional Theatres) A, and where shows are worked on for long periods of time before they open. In these situations, there will be at minimum a *lighting designer* and a separate *master electrician* who direct the artistic and technical aspects respectively. An *assistant* and/or *associate lighting designer* will almost always be on hand, and the *master electrician* also will usually have one or more *assistant master electricians*. There will usually be a

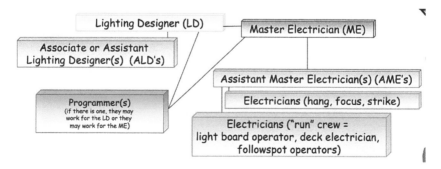

Figure 5.8 Typical theatre and live, produced performance lighting team organizational structure

light board operator, who stays with the show after the rest of the team moves on, often a separate *programmer,* and a large team of *electricians.* Having technicians dedicated solely to programming is becoming more and more common now, especially in musical theatre and spectacle productions where the technical skill required to program is quite complex.

As we scale down in size of operation, or branch out into other related live genres like opera, dance, certain kinds of event production, or the variety of small scale spectacles and immersive work that are out there, the job definitions generally stay the same, there are just fewer people and fewer assistants. A job that gets added to some situations is *lighting director.* The title is such a convenient catch-all that you shouldn't assume anything when you hear it. It usually contains at least the administrative responsibilities of a master electrician, with an expectation of design ability. In touring shows that don't travel with their own equipment, the lighting director is usually someone who is expected to make design decisions from venue to venue, but didn't design the show. It can be a great job for an aspiring lighting designer because they create the same design again and again with a different set of gear at every stop. This is what I did for *STOMP* for many years, and it's how I learned what lighting equipment can really do. In television, the lighting director is usually in charge of lighting operations, much like a master electrician, sometimes reporting to a designer, especially in live event broadcast, but often to the director. They are usually charged with calling instructions to other lighting technicians during broadcast or recording.

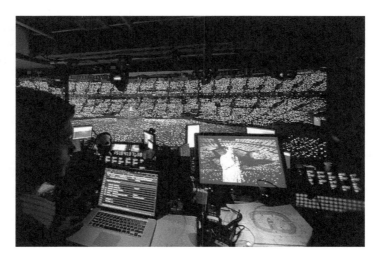

Figure 5.9 Travis Hagenbuch (see Chapter 3 Pro-perspective) as Lighting Director
Courtesy of Travis Hagenbuch

the first ones who have to bring things to the table. No matter how collaborative the team is from the beginning, the person designing the environment has to create a framework before the other designers can go very far.

It is crucial in creative teams that the collaborators allow each other's processes to breath. Collaborative creative work is both an introversive and extroversive process in that each collaborator needs time to themselves to process ideas. If one designer in the group is too controlling, it can disrupt the process of another. If anyone on the team is unengaged, but then critical of decisions that were made while they weren't paying attention, that can sour the others' willingness to be open about what they are thinking. One of the more common train wrecks in a live performance design process happens when people sign off on things they haven't taken the time to fully look at. This seems to happen more frequently as remote design gets more common. Everyone on the team has different due dates and are working on multiple projects. If they fail to fully engage in the process because they are busy and their due dates are further out, it can cost the whole team. As a collaborative artist, you should be able to expect engagement, thoroughness, and a willingness to communicate from your collaborators, and they should be able to expect the same from you.

Working with the Rest of Your Team

A technical director I once knew had a sign over his door that said, "The key to good leadership is to surround yourself with people who know what they are doing and then let them do their jobs." This is easier said than done, but I've always found the spirit of it to be accurate. As with the director being praised or blamed for the success of a creation, even though they don't have complete control over everything that happens, the lighting designer will be praised or blamed for the lighting even though they usually can't get it done by themselves. When I can surround myself with people who understand how I work, who are as committed to the success of a production as I am, we are most effective if I let them do their thing. As with the interaction with the director I described above, I often have terrible ideas that my team tries to talk me out of. Trusting each other to be motivated by a desire to get the best possible design product is key. The person in charge has to take responsibility for the decisions made, but the more any leader can rely on and count on their team, the better the quality of work will be.

Sometimes you will have people assigned to you who are in it for different reasons or maybe just aren't up to where you'd like to set the bar.

When this happens, you may have to make some judgment calls about what can be accomplished. You may be able to go back to a producer later to let them know that someone on the team wasn't up to the task, but in the moment, it's still your responsibility to put a good product in front of the audience. In a "not my finest hour" moment after I had been on the road for many years, a local promoter had cut so many corners on the team and the equipment provided that I lost my temper. I said I was going back to the hotel until a minimally qualified crew was hired and the rider requirements were met, and I didn't care if we opened that night or not. You can applaud my bravado if you want, but when I got back to the hotel, I remembered the several thousand people who had paid to experience the show that week and my employers who would be forced to replace me if they had to refund those tickets. So I went back. I took a deep breath, re-grouped the team and got something like the intended design on the stage for the eager audience. Thankfully a management debrief put policies in place to try to avoid such a thing happening again, but I would not have been able to have that conversation if I had stayed in my hotel room and let the show go down. Remember that this kind of work is a team activity and that "it's not about you". Be passionate, be firm, but be kind and get the job done.

History Break: Jules Fisher, and Jules' "Dos" of a Good Lighting Design

In the Tharon Musser History Break, I mentioned that there were two legendary lighting designs up for Tonys in 1975 when she won it for *A Chorus Line*. In any other year, Jules Fisher would probably have had a Tony for his *Chicago* design, which was also a significant leap for our industry in terms of aesthetics. He won nine others, though, most recently in 2013, and was nominated for many more. And because he also designed the lighting for the film *Chicago* (with his frequent co-LD Peggy Eisenhauer), his unique mastery of design is captured for all time. Even if that weren't the case, his many contributions to the field of lighting design ensure his place in the history books.

In addition to his artistic achievements (from *The Designs of Jules Fisher*) – conceptualizing the "light curtain", patenting the first moving light, significantly advancing the abstract, or concept lighting design

aesthetic, to name a few – Jules Fisher is credited with lighting design finally being recognized as its own profession by USA829, which took years of wrangling.

Fisher created Broadway Lighting Master Classes in 1994, he has said, following his frustrations with higher education. He wanted a more intensive experience taught by his many accomplished colleagues. You may remember a previous Break that this is where I attended the revelatory color lecture by Jules' friends Beverly Emmons, Clifton Taylor, and Stan Pressner. Fisher would often kick off the event with inspiring welcome speeches. One of my favorites from my notes is six short and sweet rules he shared for effective lighting design:

1. Make it beautiful
2. Make it interesting
3. Find the unobvious
4. Reveal through contrast
5. Provide variety
6. Use the beauty of simplicity

Take a Breath: Reflections and Trailheads

Reflections

- Intention, analysis, reference research, scene or moment breakdowns, "conceptual hook-ups", inspiration boards: What methods will you employ to generate ideas and communicate with your collaborators as you approach your design?
- Reference material, acting areas, angles, focus points, systems, specials: How will you organize your resources as you lay out the light plot?
- Teams, organizational structures, time: What sorts of creative environments excite you and are you suited for? If you're not suited for the environments that excite you, how might you adapt to achieve your dreams?
- Collaborating with directors, other artists and stakeholders, and your team: What kind of collaborator do you want to be?
- What did you learn in this chapter that you'd like to know more about?

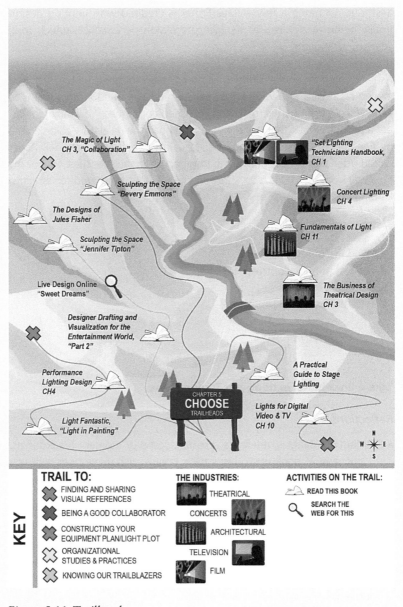

Figure 5.11 Trailheads

challenges you anticipate needing to spend time on, your preferences for order of operations, others' preferences for order of operations, and the vocabulary you will use. The common term, "working", for instance, is one that prevents frustration. Because our work is often done in the dark or near-dark, the people calling a focus often cannot see what the focuser is doing. When a technician has to spend a little more time getting the equipment to do what the designer wants it to do, firmly announcing "working" will let everyone know that work is being done. The focus caller can do something else for a moment or move to another focuser.

For the designer/focus caller, saying: "OK, pause. New idea now" is one of the greatest communication tips I ever learned. (Thank you, Santa Fe Opera.) Here's why. Sometimes you will find yourself fighting with a focus, realize the light isn't going to do what you want it to do, and you'll decide to go to plan B. When your team is really committed to trying to get what you want, they will not know you are changing the goal unless you make it clear to them. The new instructions may not make sense in the context of the original instructions and result is frustration and wasted time. A momentary pause to wipe the slate clean will let Plan B start fresh. These may seem like small things, but working with a well-tuned focus team can be exciting, saves the producer's money, and gives you time back to work on the art of things. Precise communication is how you achieve it.

The "Tech" Period – Getting It Done While Everyone is Staring at You

During an interview for an article I wrote on contemplative practices for designers, Maranda DeBusk, a graduate design student at the time, joked, "the tech table is the nucleus for all negative energy. The lighting tech table is always where everybody crowds, and everybody wants to stand over your shoulder and everybody wants to tell you how to do your job. . ." It takes a lot of courage to choose this work but eventually, when you're good at it, and if you take up quietive practices, you might be a collaborator who makes that environment better. Maranda's grad school classmate at that time, Kristen Geisler, told a story about tech table tension while assisting their teacher, Kenton Yeager, who is a long-time meditator: "it was amazing to me watching him . . . He didn't react to it . . . He absorbed [the director's] nervousness – sort of flushed it back out in that very calm way."

The thing to remember about these moments is that the other people in the room don't really understand what the lighting team is doing. Even if they have some understanding of how light works in art, they rarely understand all that technical shorthand that the team is using to

materialize the ideas. They have to relinquish control and that's a scary place for them when lighting can make or break their work. The more you practice being the calm at the center of the storm, the more successful you will be, and the more other people will want to work with you.

Being able to work calmly may be a factor of your quietive practices, but being able to work confidently will depend on your understanding of the technology and how you prepare. Don Fox is one designer and teacher who has spent a lot of time thinking about how to prepare. His Pro-perspective will lead us into live level setting proficiencies.

Pro-perspectives: Don Fox, Setting Up the Console, and Pre-Programming – "Making the Salad Bar"

I sometimes refer to pre-programming the lighting console as being similar to making a salad bar. The chef will have the team chop vegetables, prepare dressings, slice fruit, assemble cheeses and pickles. All of these things need to be arranged for easy access using a layout best suited to the situation, whether the scale is a gathering of a few friends, a fast business meeting luncheon for 50, or part of a lavish wedding feast.

Likewise, it is valuable to pre-program the lighting console or show file with containers for all of the "ingredients" that we think we will want to quickly access, arranged in an intentional manner, so that we can efficiently manipulate the light to serve the production at hand. Ideally console prep begins with conversations between the lighting designer and the programmer early in the production's development. The conversation should include straightforward connectivity questions like which fixture personalities to use or how granularly the LEDs should be patched, but also more complex preferences like pre-programming facelight presets into inhibitive subs so that keeping actors in isolated key light is more quickly achieved during tech. If the designer is to serve as programmer then they can start a show file ahead of time using an offline editor for that console.

The consoles that I'm most comfortable working with are ETC's Eos Family, so I'll continue to use that terminology here, but every major console on the market has similar versions of these programming containers. Understanding the capabilities, quirks, and syntax of the console is critical in being able to make efficient choices during pre-tech preparation.

Lighting consoles already suggest the direction for this conversation with keys, buttons, or storing locations with names like "Group", "Effects",

"Focus Palette", "Color Palette", "Beam Palette", "Int Palette", "Preset", "Sub", and "Macro".

Decisions also need to be made regarding Show Control (both inbound and outbound), user interface choices (including saved Snapshots, Direct Selects, and onscreen Magic Sheets), Setup options (like default timings, home presets, and marking options – often called Move In Black or MIB) and recording defaults so that when you update you know exactly what ripple effect your changes will have throughout the palettes, presets, subs, macros, and cues in the show file.

How we plan to fill and arrange/number the recording containers and what we choose as the console default behaviors will be greatly influenced by the kind of production for which we are preparing. The console prep for *busking* (lighting on the fly, in response to live performance) a music concert will be substantially different to the pre-programming we might do for a musical theatre production to be left in the hands of the show crew (because we are turning our work over to operators).

The approach to pre-programming the console will also vary according to what kinds of fixtures will be in the rig. If a light plot has only conventional fixtures, it doesn't mean that the console prep for that show is any less important, it just addresses different concerns. Even fully conventional rigs will be much more easily handled if there are groups, subs, intensity palettes, and presets already envisioned and prepared for filling once the rig is focused and level setting begins. For rigs of moving lights and LEDs, it is critical to pre-program the console so that as much is done prior to tech as possible. With pre-vis software available and focus tools like Augment3d from ETC being built right into the boards, there is a lot that can be programmed prior to tech and then tweaked, rather than starting from scratch.

When giving consideration to your console setup, think about what the show is going to require you to create quickly based on the visual language that you and the director have agreed upon. Then, like a salad bar, make sure you've got everything you need prepped and laid out so that you can quickly serve up a fresh and tasty lighting design!

Some Common Live Level Setting Proficiencies

In Chapter 4, we talked about basic lighting control in the context of channels, groups, etc. In the last Pro-perspective, Don Fox added the more advanced concepts of *palettes* and *presets*. These are all ways in which a

lighting console arranges control information. Advanced programming is beyond the scope of this book – and there are great tutorials and webinars out there for every type of light board, so I won't go into great depth about any of that here, but there are some common strategies with which you should be familiar.

Unless a design has less than a couple dozen channels, designers don't usually memorize channels, groups, or other containers. They number the containers in ways that make them easier to recall quickly, and then use a tool for fast recall a *magic sheet*.

The *Hands on a Hardbody* magic sheet in Figure 6.1 is one example of a computer-drafted paper magic sheet but there are lots of digital options and onboard console options. Each lighting designer has their

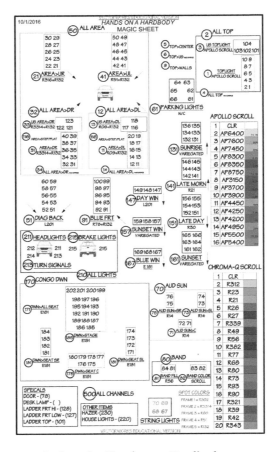

Figure 6.1 Paper magic sheet for *Hands on a Hardbody*

Drawn by Associate LD Daniel Kersh, after a template borrowed from his internship supervisors Laura Bickford and Stacey Boggs

own preferences about how they like their magic sheet laid out, but there is usually enough commonality that any trained lighting person will be able to extract information from it. In this example, the primary data are the channel numbers, but there are graphic elements which aid in drawing the designer's eye to the right place quickly. Every choice in the layout is deliberate, including having the backlight nearer to the top of the page than the front light, because this echoes the physical layout of the theatre.

How a cue list is planned depends on designer preference and the scale of the show. At a minimum, if an experienced designer were to be lighting a small play with few cues and they were confident that there would be plenty of technical rehearsal time to set levels and refine them, they might simply pencil into their script where they plan to have cues along with some notes that help them remember what they mean for the cues to look like. When the time comes, they take their script and magic sheet to the tech table and start cueing. As production scale goes up and/or time to set levels is tight, more preparation is required. What that looks like is highly personalized, but I recommend (and for my students, require) a prepared cue list. The more detail the designer thinks through ahead of time, the fewer things they will have to decide while everyone is waiting, and the more time they will have to make the design great.

For the extremely detail-oriented, there is a technique I employ called *dry cueing*. Dry cueing involves guessing the level we will want groups or channels to be at without seeing it. The levels will almost never be right, but all the decisions of what ingredients are needed for every cue are already made, so that when we sit down at the tech table, all we have to is dial in the refined levels of those channels as they come on. These leaves more time for the finesse of the design (sculpting, timing, etc.), which, for me, is the fun part. Be warned that dry levels should be very broad strokes. You will rarely get them "right" before you can see them live and you will later kick yourself for wasting the time trying.

Whether I am dry cueing or doing it live, I usually like to do it in this order: first the background, then backlight. (Even in a dark cue you'll almost always want at least a little background and/or backlight because that's what separates objects from the background and keeps your performers from floating in space.) Next is whichever side or front light I mean to be key; then whichever side or front light I mean to be fill; and then specials or accents or scene-specific touches. The starting levels are usually in the 25–75% range (25 for fill and 75 for key). Never start with anything at full or you'll have no way to go up when you want something just a little brighter.

When dry cueing, I don't recommend spending time guessing levels of color systems you intend to blend. Just set them both at the same level, or set the color you know will be dominant at a higher level, and adjust

when you can see it. No matter what system you are turning on, make a guess, set it, and move on. Don't agonize over it. Dry cueing is simply a way to avoid starting from scratch, not a way of trying to win the game before it has even started.

Presets and *Palettes* are more complex containers, which allow changes to be made more globally in a show file. This saves a considerable amount of time when you are working at a large scale or have a large number of repeating locations. It works like this. The designer sets a preset or palette (depending on the syntax of the board and what the designer wants to do with it), then creates a reference to that preset or palette in the cues that need that particular set of levels (so maybe all scenes in a particular location at a particular time of day, for instance). Then when the designer is live cueing and makes a change, that change gets made for all the cues with that reference point. Or another use would be on tour where the relative spatial relationship between moving lights and a focus point might change from venue to venue. If each cue that uses the same focus point references a focus palette, then you can simply update the focus palette and every cue will be automatically updated.

The tools *Cue Only* vs *Track* are concepts that keep beginning designers up at night, but everyone will tell you that it's not hard once you put the time in to understand it. To demonstrate what these two choices mean and why you would choose one over the other, let's go through a common scenario. You are in tech rehearsal and you have already set levels for a sequence of cues within a scene. As the scene progresses, it doesn't change location or time same time of day, but needs several cues because it requires small changes in selective focus. As the tech rehearsal is happening and you are somewhere in the middle of that sequence, you decide to adjust the color of the background – maybe it doesn't feel enough like night. Everybody loves the change and it is agreed that that is the right background color for this scene – the *whole* scene. If you change it in that cue only (hence the syntax "cue only"), then when the next cue in the scene happens, the color will change back. Until you have embraced tracking, there will be an awkward gasp, a flurry of activity at the tech table and everyone in the room wonders if you know what you are doing. The director thinks: "I thought we agreed that was the right color, why did the LD change it back?" You didn't "change it back", you just didn't change it *forward*, but only the lighting people know the difference. *Tracking* the change avoids this.

This makes sense, right, so why should it be scary? The scary part is the time-consuming mess created when you track something BEYOND the scene you are working in. It will happen to you at some point and it will be stressful to clean up, but once you understand how tracking works,

the time you occasionally spend cleaning up a mis-track will be much less than the time you would have had to spend adjusting each individual cue.

The key to avoiding tracking errors is another command tool usually called *Block*. Blocks often go on a scene transition cue, or if there is no transition, then the first cue of the next scene. Blocks should go wherever there is a significant shift in overall levels, because that's where the designer is most likely to want a tracked level stop tracking. Think of the block as a wall stopping any new level barreling toward it. It prevents a change of level IN the blocked cue AND beyond. And if you are tracking backwards (often called *Trace*), the block will prevent tracking back into the last scene. There are more nuanced kinds of blocking functions on some boards, but this is usually how it works. If you have blocks in the right places, whenever you are about to update a cue with a change you made, you can just pause for a moment to determine if the change you made should be a one-time change (such as a special coming on) or a change for that whole scene. You can even pause to check for where the next block is and insert or remove blocks before you update. If it's that rare one-time change, you activate the cue only function, but the rest of the time, you just *enter* and let it track. The new level will track through until it hits a block. It's really that simple and you will get used to it quickly. If you make the wrong choice (and you will sometimes), and you realize it right after you hit enter, just "undo". And remember, if you ever track something into a scene that you don't mean to, you can always track it back out again. So there's nothing to fear!

Editing in *blind* – so called because you cannot see the changes happening, as opposed to *live* (both are menu choices on most light boards) – is another intimidating but necessary skill. This usually happens because the rehearsal has moved on, but you didn't get to make a change you wanted to make live. If you're thinking ahead, you may realize that a change you made in a cue needs to change in several more out-of-sequence cues. In the earlier example of the background color change for instance, if that look is repeated again later in the show, the change may need to be made there too. A real pro anticipates those necessary changes and would like to have them made before the rehearsal gets to that moment, so they make the changes *in blind* or *not live*. Another "pro-move" is to do notes in blind while other departments are working. For example, the rehearsal might be paused for an automation challenge that needs worklight, which leaves the lighting designer on pause. A pro takes advantage of this time to make whatever edits that they are able to make in blind.

Knowing when to *ask for a hold* (a stop in the rehearsal) and when to *take a note* is another skill to cultivate. If you don't ask for the holds you need, you may not be able to get the note done accurately, but if

you ask for too many holds, you won't have a real-time sense of what you've got, and other departments may not be able to get done what they need to. There are a number of factors to take into account. Will you be given the time you need to do the note if you don't call for a hold now? Do you need the performer in place to make the change? Do your collaborators need to see change? (Either because you need their agreement or because they will get nervous if they don't see you making changes. This often happens with directors who don't know their designer well. They may ask for a change and if they don't see it happen at that time, they may get nervous about whether or not it will get done or look like they imagine.) Is the note simple enough that you can do it now or does it require some problem solving? Or does it require a work note, like a re-focus or physical color change to see the final result? Can you do this note in blind next time someone else needs a hold? Not everyone agrees with this, but I usually say if you don't *really* need the hold, don't call for it. Some designers feel entitled to hold for every little thing, but I'm not one of them. I find that excessive holding makes it hard to see what I've created in context and I work efficiently in blind anyway, so why would I want to drag out the rehearsal unnecessarily or counter-productively?

The last conceptual skill I want you to think about is *letting go*. Jules Fisher is often quoted as having said that "designs are never done, they just open". What I'm NOT suggesting is that you call your design "good enough" when there is still time left, but what I am suggesting is that you be intentional about when you call your work "done". In the professional theatre model, a show is meant to be *frozen* once it has its official *opening*. The idea is that at that point, the cast and show crew need to be allowed to do their job for the paying audiences without chaos of a new idea. There are many other models, dance being one of them, where changes might happen during the run of the production. This works in dance because dancers usually remember a change without needing much repetition, the performance runs are usually shorter, and the light board operator is often the lighting director or designer. In the professional theatre model, it is expected that changes will happen and be rehearsed during the preview period, but I have seen many examples in academic theatre in which changes were made but NOT rehearsed, resulting in the audience seeing a change on opening night that didn't go quite as expected. So context matters. Be sure to take a risk assessment and ego-check before you make a big change late that doesn't have time to be rehearsed. If a change will have a big enough positive impact that it is worth the risk, be extra attentive that everyone else has the time they need to adjust.

Reflect

If we take the time after each endeavor to self-reflect, we fuel growth. Chapter 7 examines some of the ways to do that.

Markers of Success

Before you can decide if you were successful or not, you need to decide what success means for *you*. Is it a big award that you want? To be written about? Praised by your loved ones? Or your colleagues? Big paydays? Big audiences? A cheering crowd? An affected viewer? Apparent social impact? Successful students? Making meaningful creations with just-as-dedicated collaborators? Ponder that while we explore some considerations.

Even if we're not in it for the money, unless we are independently wealthy, there are a few things most of us have to do in order to be able to keep doing what we love. The broad question for me are: did I accomplish what I meant to accomplish? Did my work contribute to the broader work that it was a part of? And did my collaborators and I get where we meant to get? Was whoever was footing the bill satisfied with what they spent their money on? If the people I worked with had the opportunity to work with me again or recommend me, would they?

This is a challenging business to be in. The demands are high and we spend long hours together. I've often heard designers say that when they're interviewing assistants, more than anything they're wondering if they can sit at the table with them for hours, days, and weeks on end.

DOI: 10.4324/9781003022725-11

Some people can become negative under strain and that can make others wonder if what they're doing is worth it. You know who the people are that *you* want to work with. How can you be the person that they want to work with?

Learn to Seek Out and Receive Criticism

The question of how well you contributed to the story or intention can be a trickier question than you think. It requires that you be willing to see from multiple viewpoints and make sense of contradictions. Some creative people will tell you to just do what you do and let the audience take care of itself. There's an expression: "What people think of you is none of your business." There are contexts in which this expression makes sense, but it is dangerous advice to take before you've learned your craft well. Ask people what they think and learn to be informed by it. Don't be offended if they "didn't get" what you were trying to do, rather ask yourself why they didn't get it. What could you have done differently to better take them along on the journey?

In the project "Stories with Light" in Chapter 3, I invited you to look at Joan Marcus' website for production shots in which something about light told you something about the story. Try this with your own work. Show someone a lighting look you have designed or a photo of one and ask them what they think is happening in the moment. If they are ready for this kind of question, ask them what about light might have caused them to draw that conclusion. If they understand what it means, ask for observations about the *composition, contrast* and especially the *tone* (all discussed in Chapter 3) you have created. Does what they see match what you were going for? You could ask specific questions around the choices you made in the context of the things *Light Can and Should Do* for your creation (also from Chapter 3). Can they see what they are supposed to see? Is their eye drawn to what you meant for it to be? Do they have some sense of the story, theme, or intention? Etc. Or you could use Jules Fisher's rules as discussed in Chapter 5 and ask if it is beautiful and/or interesting? Unobvious? If you have several moments of the same show, ask them if they see some variety? And so on.

This clinical exploration is one way to take some of the anxiety out of receiving critique. Another is to remember that you don't have to agree with what you hear and that even though negative critique *may* be an indicator of how successful you were in that project, it isn't necessarily a reflection of what you can do next. It's quite the opposite, because if you can openly receive criticism and honestly reflect on it, your chances of succeeding increase tremendously. From my years of reviewing student portfolios, I can tell you that the students who can receive feedback,

converse comfortably about their work, and tell you what they would have done differently are the ones who are ready to thrive.

Documenting Your Work

For archival photographers, the most important subject is the performer and second is the environment. Light for them is a tool to achieving good exposure and contrast, but not always the subject. For your portfolio, light has to also be a subject. Reflect back on production shots you have tried to evaluate, perhaps again from the *Stories with Light* project. What sorts of camera shots allow you to see what you needed to see in order to evaluate the lighting? Closeups? Wide shots? Centered shots? Angled shots? High horizon line shots? Low ones? Highly exposed shots? Dark shots? You probably realize that a variety is most useful and that having only one kind of shot doesn't tell you much.

Consequently, it's a good idea to learn to take your own shots. It can be hard to prioritize this when you're trying to get the design done, but may be your biggest regret if you don't. This takes financial commitment because you'll need a camera – one that works well in low light and high contrast situations. There is skill involved in shooting low light images that are not grainy or out of focus, so take a class in camera techniques if you can. I shoot in *manual* setting and *raw* format (as opposed to jpeg). Manual, so that I can live adjust depending on the relative light levels of the scene, and raw, so that I can make more precise adjustments to the pixels later. Even the best cameras today cannot see what the eye can see and so post-developing involves correcting for that. One of the most common things you'll do is bring the exposure up on the shadows and down on the highlights to resolve the high contrast of theatre lighting which the camera doesn't usually resolve on its own. If you have a camera phone and haven't tried this already, play with those functions. You'll see that a tiny amount of adjustment on the shadows and highlights can make a too dark and/or too washed-out image look right again. If you have access to Adobe Photoshop software, another good tool is *content-aware fill*. This will allow you to remove the head of someone interrupting the bottom of your frame or the cable that was hanging down the night you shot.

Ready to Do It Again?

Now that you know what success means to you, have documented your work and gotten feedback on it, it's time to do it again. The next design will be even more exciting. You have made choices, evaluated the outcome, and now you're ready to make new choices. Never stop learning, trying new things, and reflecting.

History Break: Who is Missing?

A proper history of significant lighting designers could fill several books. The History Break subjects in this book are all people who impacted my career and whose stories I brought with me into the classroom. There are many more influential lighting designers whose stories could impact your work if you explore them: Martin Aronstein, Abe Feder, Peggy Clark, Tom Skelton, Gilbert Hemsley Jr., Richard Nelson, John Gleason, Arden Fingerhut, Howard Brandston, Chris Parry, Howell Binkley, Patricia Collins, Shirley Prendergast, Natasha Katz, Peggy Eisenhauer, Ken Posner, Don Holder, Brian MacDevitt, Peter Kaczorowski, Robert Wierzel, Rick Fisher, Allen Lee Hughes, Kathy A. Perkins, Ken Billington, Paul Gallo, Paule Constable, Neil Austin, Jane Cox, Luc Lafortune, Max Keller, Bill Klages, and James L. Moody. I also suggest you check out Fred Foster, Sonny Sonnefield, and Anne Valentino. These are people whose impact I have some knowledge of and there are surely many more I haven't given their due honor.

Now I want to dig deeper into the question of who's missing, making the transition with some of my own self-reflection.

There's something wrong with the final inventory of people I have chosen for the History Breaks and Pro-perspectives. They are all white. I explained how I chose the History Break subjects; they are people whose work impacted mine over the years in direct ways. I read their books, saw them speak at conferences, or were introduced to them in some way by the people I worked with. The Pro-perspectives list started with my strong network of former students and colleagues who I knew would write with a voice that was uniquely theirs. In the first outline draft of the book, it quickly became clear that women were not well represented in the line-up of "pros", but that part wasn't hard to solve. I have plenty of successful professional female colleagues, they just aren't as outward-facing as my male colleagues and so they were not the first ones I thought of. I tell you this because it is a good subject for us all to reflect on – people who keep quiet often go unrecognized unless we challenge ourselves to look further. It is important in all things that matter that we push past the first answer we come to.

What wasn't immediately clear to me was that there wasn't a single BIPOC lighting person I know well enough to call on. I'm sorry that I didn't wonder until I started writing this book how the few non-white students I have had over the years must have felt doing these reading assignments and never once reading about a person who they identified with in that way.

One of Perkins' mentors was Shirley Prendergast, who passed in 2019. Prendergast was loved dearly by those she worked with. Perkins wrote in a 2019 article that Prendergast got into lighting when taking a course to inform her photography, and that she was the first African American woman to be admitted as a United Scenic Artist lighting designer. Her career spanned more than five decades and just about every kind of live performance. Her first Broadway credits start in 1971 and she assisted Skelton, Gleason, and Tipton (IBDB). She is credited with six Broadway designs of her own but that doesn't scratch the surface of how much creative work she generated and the number of young professionals she influenced.

As an educator, I keep asking myself how we can do a better job ensuring that aspiring Black and POC lighting designers make it into the profession and want to stay. One young student I believe will be in some future History Break is Amara McNeil. When she was applying to undergraduate schools, Amara wrote an application essay that caught my attention for its honesty and courage. She didn't become a student in the program I was teaching, but she and I kept crossing paths in other ways. In the short time I've known her, her perspective has had a strong influence on mine. I asked her if she would develop an essay for this book about her experience as a Black student of lighting. I want her words to close this chapter on reflection.

Aspiring, but-not-yet-Pro-perspective: Amara McNeil

I clearly remember the first time I ever "lighting designed" a show. I was in the tenth grade and barely knew what stage lights were, never mind how I could use them to tell a story. Flash forward four years later, and I am still learning. While I have been lucky enough to learn so much from a multitude of mentors, teachers, and fellow designers, there has been one essential part of my education that is missing: What does it mean to be a Black female lighting designer? How do I become a racially aware designer when it seems as if there are little to no resources to pull knowledge from?

In a recent conversation with a fellow Black female lighting designer, I asked her how she learned to light for skin tones other than white. "I taught myself." She completed over seven years of lighting design training, yet she still had to teach herself how to light over 40% of our country's population. I refuse.

Through conversations with various mentors, professors, and peers, I have found lighting to be an industry in which you are pressured to take unpaid internships regardless of the unfair financial burden it puts on low-income students. It is an industry where in looking for a mentor, you will almost always find a cis white man because anyone else is too far too few, where a student can go through both undergraduate and graduate school and is never taught how to make every skin tone look beautiful on stage.

For our industry to embody what the country looks like, a country which is almost 40% non-white, the modes through which we teach and think about lighting design need to adapt (US Census Quick Facts). From mentorship to color theory, we need to make lighting design more accessible for BIPOC students. As a designer, look back at your work: Have you worked on shows that have challenged you to light skin from the palest of pale to the darkest of dark? Are you prepared to make every actor look their absolute best regardless of skin tones? As a teacher, look at your curriculum: Are you training your students to effectively communicate a story while simultaneously making every actor look their best? Are you advising your students to demand compensation for their work and not fall victim to unpaid internships' unethical practices? Are you, yourself, willing to commit to not working for companies which utilize unpaid labor?

While I am young and still learning so much about lighting design and theatre, I know what type of industry I want to be a part of. I want to see an industry that does not rely on unpaid internships or unpaid labor. I want to see an industry where a woman's ability to match the physical strength of a man does not determine her creative worth. I want to see an industry where I do not have to teach myself how to make my fellow Black kings and queens look their best, sun-kissed, and powerful. It will take some intense pedagogical shifts and industry-wide accountability. However, I am ready; I hope you are too.

References and Resources

"A Conversation on Diversity and Anti-Racism in Entertainment Design." *United States Institute for Theatre Technology*, www.usitt.org/news/conversation-diversity-and-anti-racism-entertainment-design.

BIPOC Arts Database, www.bipocarts.com.

"Equity, Diversity, and Inclusion in USITT." *United States Institute for Theatre Technology*, www.usitt.org/usitt-edi.

"Lift the Curtain: Breaking the Business of Unpaid Internships." https://youtu.be/dXeJyv6jQsw.

Lu, Jackson G., et al. "'Going out' of the Box: Close Intercultural Friendships and Romantic Relationships Spark Creativity, Workplace Innovation, and Entrepreneurship." *Journal of Applied Psychology*, vol. 102, no. 7, 2017, pp. 1091–1108., doi:10.1037/apl0000212.

Marcus, Joan. joanmarcusphotography.com.

No More 10 out of 12's USITT Online Series:
 "Why It's Time for Change": https://youtu.be/vxgu-oVM-z8.
 "Impact on the BIPOC Community": https://youtu.be/sQE1q-kP1So.
 "Impact on the Disability Community": https://youtu.be/772gbNDeucw.

Perkins, Kathy A. kathyaperkins.com.

Perkins, Kathy A. "Trailblazing Lighting Designer Shirley Prendergast Passes." *New York Amsterdam News: The New Black View*, amsterdamnews.com/news/2019/apr/04/trailblazing-lighting-designer-shirley-prendergast.

Pierce, Jerald Raymond. "Lighting Designer: Allen Lee Hughes." *American Theatre*, 20 Nov. 2019, www.americantheatre.org/2019/11/19/lighting-designer-allen-lee-hughes.

Pierce, Jerald Raymond. "Yes, Lighting Design Has a Diversity Problem." *American Theatre*, 27 June 2018, www.americantheatre.org/2018/06/19/yes-lighting-design-has-a-diversity-problem.

Production on Deck, www.productionondeck.com.

"Resources for Racial Diversity, Equity and Inclusion." *League of Resident Theatres*, lort.org/edi-resources.

"The Tony Award Nominations." *The Tony Award Nominations. The American Theatre Wing's Tony Awards®*, www.tonyawards.com/nominees/year/any/category/lighting-design-play/show/any.

"U.S. Census Bureau QuickFacts: United States." *Census Bureau QuickFacts*, www.census.gov/quickfacts/fact/table/US/PST045219.

Unruh, Delbert. *The Designs of Jules Fisher*. USITT, 2009.

We See You W.A.T., www.weseeyouwat.com.

Xavier Pierce Design, xavierpiercedesign.com.

Inspiration

A commercially financed study by teachers at University College London in 2017 found that the heartbeats of audience members at a production of *Dreamgirls* synced up with each other. It's a great marketing story, but in reality it isn't an "out there" idea. Previous scientifically reviewed research suggests that heartbeats can sync up in all kinds of situations when there is sufficient human connection.

As a teenager in the mid-1980s, I was a followspot operator for a community theater production of the musical *Cabaret*. I had spent hours in a basement doing lighting work I didn't totally understand and was rewarded with a show crew position. I remember on opening night that I was following the lead character Sally Bowles with the spotlight as she belted out the climactic number of the show. The audience was riveted, I was precision focused, and when she got to the final phase of the song, the lights I had spent all that time on in the basement began to chase, the orchestra and Sally gave it everything they had, and the energy in the room was electric. You know what I'm talking about. You've felt it. It's why you're reading this book. The connectedness I felt in *that* room that day inspired my life journey. It doesn't have to be theatre, or even entertainment for that matter, and it doesn't have to be live. But creative work is particularly capable of causing transcendent and connected experiences.

It called to you, so how are you going to answer that call?

DOI: 10.4324/9781003022725-12

History Break: How Will You Make Your Mark?

This last History Break is yours. I often ask my students to write a "future bio". It's ten years in the future and you are writing your bio for a program or website. What does it say? I do this so that I can get a better idea of how I can serve them, but they find some clarity through it, and I invite you to do the same. What matters enough to you that you want to achieve it and make sure everyone in the future knows about it? What do you want the future textbook author to tell the aspiring lighting artists about you?

Take your time with this one, and maybe ponder it for a few days. Remember that it won't set anything in stone; you can write a new future any time! Use it as a chance to consider where you are in this moment and where you might be going, but know that it is pliable.

Thank you for going on this journey with me. I wish you success and joy in whatever you do with it.

Now get ready for *your* History Break. Take some breaths, reflect on what you've learned, the choices you've made, and the choices yet to come. Then, from *here*, *begin*.

References and Resources

University College London Division of Psychological and Language Sciences. "Audience Members' Hearts Beat Together at the Theatre." *UCL Psychology and Language Sciences*, 1 Feb. 2019, www.ucl.ac.uk/pals/news/2017/nov/audience-members-hearts-beat-together-theatre.

Appendix 1

How Do I. . .

Hang Lights?

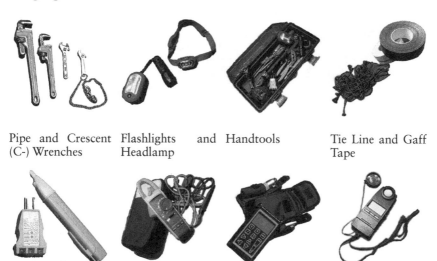

Pipe and Crescent (C-) Wrenches

Flashlights and Headlamp

Handtools

Tie Line and Gaff Tape

Voltage Sensor and Circuit Checker

RMS Meter

DMX Tester

Light Meter

Common Tools

Getting It on the Hanging Position

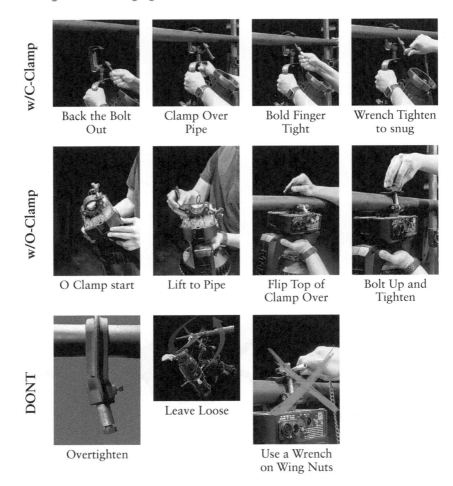

w/C-Clamp	Back the Bolt Out	Clamp Over Pipe	Bold Finger Tight	Wrench Tighten to snug
w/O-Clamp	O Clamp start	Lift to Pipe	Flip Top of Clamp Over	Bolt Up and Tighten
DONT	Overtighten	Leave Loose	Use a Wrench on Wing Nuts	

Finishing the Instrument/Fixture

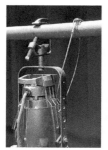

Safety-
Conventional

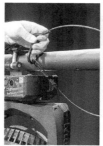

Safety-Movers

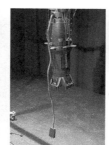

Tail Hanging
(Until Cabled)

Shutters Out

Focus Knob
Functional

Par Bottle
Moveable

Check Focus
Range
(After Cabled)

Common Mistakes

Safety Left Off

C-Clamp Loose

No Focus Slack

Connectors Away
from Instrument

Shutters Closed

Not Plugged In

Hardware Too
Tight

Connector Not
Seated

Cabling Dos and Don'ts

Do

Keep Connector
Near Clamp

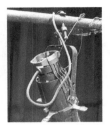

Leave Focus Slack

Dress Excess

DON'T

Tie the Connector
into a Bundle

Leave Cable
Excess Hanging

Coil the Cable
into a Tight Circle

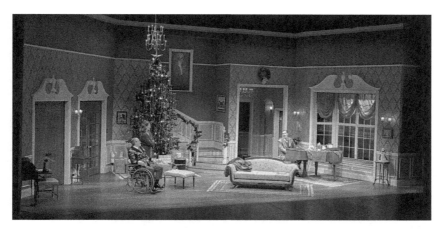

(Continued)

The unit set, upstage of the main drape and parallel to it, with side walls at an angle, allows for great sightlines from every seat in the house and as-good-as-it-ever-gets (when there's a set) lighting angles. This type of traditional layout is so lighting friendly that it allows for accurate focus of the lights before the set is even installed. With well-planned focus points and the marks on the floor where the walls will be, we completely focused the plot after hang, on the bare stage. This type of script lends itself nicely to this kind of design, and many older theatres were designed for just such a production.

Keep in mind that precision is critical. The walls will amplify a poor focus as uneven shutter cuts, hard edges, or disproportionate hots spots are put on display. One of the best tricks I've learned is to use ¼ cuts of frost in one side of the gel frame only. This is so that the part of the field edge that lands on a wall is a little softer than the edge of the rest of the field. Creative frost usage can do wonders to clean up stage lights on flat surfaces.

Challenging Configurations: *Hands on a Hardbody*

Flexible spaces are far more appealing to the creative artist. You'll regularly face challenges that haven't been solved before, which is both exhilarating and terrifying.

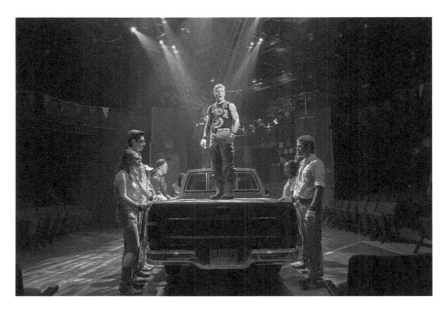

Hands on a Hardbody. Shown: Adia Bell, Brett Parker Dixon, Josh Dunn, Keenan Larson, Daniel Lopez, Connor Morley, Devon Prokopek, Dominique Ruffalo

Hands on a Hardbody was a pop musical with a full size hollowed out pickup truck that could move in all directions. The audience was on three sides, known as a *thrust* configuration, and the front row was at stage height, intentionally bringing them close to the action.

Thrust configurations are tricky to work with. One challenge common for lighting in this configuration as well as *in-the-round* is getting good illumination without blinding the audience. This is especially true if the thrust is relatively narrow, if you intend to use followspots, or if performers are going to sometimes be above floor level, all of which were the case with this production.

One successful solution was to have six followspots. We could have used more, but the logistics of six were enough to manage. Operators became masterful at *hand offs*, where one operator seamlessly fades in as another fades out, during a performer's travel, to avoid unwanted blinding or splashes of light. As with many of these case studies, there was no such thing as too much planning. We had the good fortune of being local, so we did many, many tests to get lights in good places. It is also critical in this case to argue for abundant practice time for the operators. They need time to create a shared communication with each other and they have a lot to learn and figure out.

Grass Roots to Spectacle: *STOMP OUT LOUD*, Las Vegas

If you know *STOMP*, you probably know them as "those guys who bang on the trashcans". I had the great pleasure of being part of the family for about 12 years, from 1996 when I took over as lighting director on one of the tours through 2008 after designing the lighting for the Las Vegas incarnation called *STOMP OUT LOUD*.

When a show transforms to go into a Vegas venue, one of the biggest challenges is the increased number of stakeholders. *STOMP* was always creatively controlled by the duo who started it and had been a relatively sweet and simple concept for us to tour. We had only five people on the tour production team and one truck, mostly scenery plus a heavy stock of props. The show's tagline, "see what all the noise is about", drew in full houses all over the world. Audience members left banging on everything, having gotten the message that music can be made by anybody with just about any found object.

The challenge with *STOMP OUT LOUD* was to create a show exciting enough to warrant a place on the Las Vegas Strip, but without losing the simplicity that made it great. Moving lights, scrollers and LEDs were incorporated, but the creators expected that none of that technology would draw attention to itself. It was a challenging needle to thread, but one that we worked on for months *in* the performance space. The creators generated the material on the stage with the performers and I lit, adapted, and re-lit while they developed and even the lobby became part of the show.

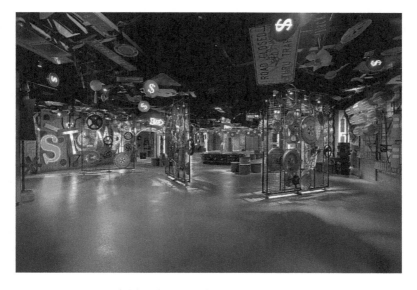

STOMP OUT LOUD lobby photograph

Don't Blind the Acrobat: Cirque Mechanics, *Boom Town*

Circus performers have a culture like no other. They perform death-defying acts and trust each other with their lives. The acrobat understands the risks of the aerialist and the "clown" knows how to check the safety nets. You'll rarely work with a company quite so tightly connected. You'll also immediately see amazing lighting possibilities. You need at least a little front light because every act has at least one – and sometimes many – applause breaks, when a performer who has just done something jaw-dropping lands face forward and lets the audience cheer for them. But what you'll also see is the opportunity for side-, back-, top-, and diagonal back light shaping of strong and sometimes contorted bodies, much like in dance.

Inevitably, if they know you're new to them, someone will tap you on the shoulder and ask you from what direction you're planning to light the act you're watching. Then they will throw cold water on your dreams by telling you that side and top light will blind them. In fact, they would really rather you get the lights in such a way that they never have to see them. Oh, and lights changing while they are in mid-air or doing something that requires spatial orientation (which is what they are *always* doing) can cause a tragic accident.

But these are also some of the most adaptive artists you'll ever work with. There *are* some things they simply can't safely adapt to, but they will tirelessly experiment with you to get a solution that looks great but lets them do their job. The close-up in the Cirque Mechanics image is an example of months of planning and experimenting, and even technical innovation. The aerialist is hanging on a device that descends and rises, at the end of a scenic beam which rotates, allowing her to make several full rotations around the entire width and depth of the stage, including over the audience. At full speed, one full rotation only takes a few seconds. When I first saw what was being created, I made my case that it was critical to have a top light special at the end of the beam, such that it traveled with her. My point was that that angle would cast light only on the floor below her, rather than a followspot which would have to chase her from a fixed location and end up splashing all over everything. It would also avoid her getting lost in a full stage wash. Besides the technical challenges of getting power to such a light, the most important question was whether or not she could safely do the act. Every time she looked up there was a bright light source in her eyes. And because she was also going up and down, her proximity to it would be slighting different each time she looked up. In the end, it worked, but we had to experiment with different kinds of lights and baffles, and she had to practice with it *a lot*. When the crowd held its breath as she floated over them, it was all worth it.

Cirque Mechanics' *Boom Town* aerialist and acrobat

Pandemic and Streaming Lighting: *Mary Shelley's Frankenstein*

When the COVID-19 pandemic upended all that we knew and hit the pause on gathering for live performance, a few brave companies showed the resilience that the entertainment industry is known for. One such company is The Rogue Theatre. Before 2020, live performance artists cringed at the idea of having our work filmed or streamed. We define theatre by the power of the live, in-person, communal, unrepeatable-moment-in-time experience.

As is the case for a lot of performance companies, the patron base of The Rogue was in the high-risk category for COVID. The Rogue produced shows during the pandemic for a reduced capacity audience with stringent safety protocols in place for everyone involved. We hung the lights in our masks, after having been temperature checked, and we had a safe word ("pineapple") that could be spoken if any of us got absorbed in what we were doing and forgot the protocols. But no amount of safety protocols can make it worth taking a chance for some patrons who are at high risk of not surviving an infection. The time had come for us to get comfortable with streaming our work.

When work is being streamed, early communication is critical. Most video professionals are artists in their own right and expectations for

their work are different than for the live experience. For example, in the theatre we intentionally create dark space to direct attention, but in video, dark space is considered an unattractive vacuum. Further, even the best cameras today still have trouble with the extreme contrast between someone in a special and a dim surround. To make matters worse, many theatrical filter colors simply cannot be read accurately by a camera. And if the production intends to use LED equipment, as most of us do now, tests will have to done to make sure there is no frame rate flicker. If the presenting company rushed out to buy the earliest, cheapest LEDs, those will likely be left in storage on a filmed production. Do a web search for LED camera flicker if you have never seen this phenomenon.

Thorough and mindful preparation along with good faith collaboration can ensure that the production is lit for the live audience and those watching on a device. Spend some time learning what videographers see and be ready to help them understand what you see. Being able to accomplish this is likely to be an expected skill for lighting designers for years to come.

Videographers filming Mary Shelley's Frankenstein during the Covid-19 pandemic

Appendix 3

Getting a Job

If you've ever heard me speak on a panel about career development, you've probably heard me say that the most valuable job relevant piece of advice that I can give you is: "Don't be an a**-hole." This is a tough and demanding business, but the people who take it out on other people will eventually run out people willing to hire or work with them. If the environment you are working in needs to change, find the appropriate channels to press for that change, but don't use it as an excuse to make things miserable for the people around you who are in the same boat. Remember that you chose this work for a reason and don't lose sight of whatever that reason is. If you really aren't getting anything out of it and are miserable all the time, you'll need to look at why that is and possibly make a change for yourself. If you don't, it will likely be made for you.

Contacts, Contacts, Contacts

The expression "It's all in who you know" is especially true in arts and entertainment. For better or for worse, the slim margins of error as well as the intimate nature of creative collaboration guarantee that people will choose to work with people they have had some work experience with already. Be brave about taking advantage of opportunities to meet and show your best side to other people in the industry. Be sure to be kind and collegial with your peers and keep in touch with them, since they may be the ones hiring or recommending you in the future.

Resources for Finding Work

Though many jobs in entertainment are heard about via "word of mouth" there are *resources* available for those who don't have their foot in the door yet. Many of the organizational websites talked about throughout the book have job boards and there are a few sites that are specifically about job advertisements. Create a bookmark menu in your browser and periodically go to those pages and see what's going on. Mine also has organizations I think I'd like to work with and organizations in places I think I'd like to live. Even if you aren't actively available for work, it will keep you current on the state of job opportunity in your fields and in regions. If you are a teacher, you should keep up for your students' sake. There are some harbingers to keep an eye out for – for instance, when employers are anticipating tough times, you may see more "multiple hats" kinds of jobs and when things are looking good, specialists are valued. If you keep an eye on trends, you'll get a sense of what kind of "hat" you or your students might need to be pulling out to ride out the next economic wave.

Always do "due diligence" before responding to any job post. Ask around about the company, check its history, and web search for news about the organization and the people you think you might be working with. It's also a good idea to know about the job board itself. ART-SEARCH, for instance, is a website that employers have to pay to post on, whereas many of the others are free. Employers who are willing to pay to advertise their jobs tend to be more established, while employers who only post on the free sites and do so often tend to have more turnover. Following are some of the relevant jobs bookmarks in my dropdown.

- ARTSEARCH.tcg.org
- OffStageJobs.com
- USITT.org (jobs page)
- URTA.com (jobs page)
- SETC.org (jobs page)
- Plasa.org (jobs page)
- Apap365.org
- IALD.org (career center)
- Broadwayworld.com (classifieds)
- Playbill.com (jobs page)
- Operaamerica.org (jobs page)
- LORT.org (no job board, but contact info for LORT member theatres)

Resume Perspectives

When working on your *resume*, be sure to look for format examples that are appropriate for the jobs you are applying to. For instance, the

traditional theatre resume usually looks like a laundry list of credits, but this is not true of technical director resumes or corporate level resumes which tend to be more descriptive in nature. NEVER LIE, but once you have more than enough work experience to fill a page, how you arrange that experience and what you include vs what you allow to drop off will tell different stories. For instance, if you have skills in a lot of different areas, be sure that the skills and credits relevant to that job are the most apparent. If the job is with a company in which "all hands are on deck" for everything – in other words, you might be applying as an entry-level lighting technician, but maybe the lighting crew helps audio or projections – be sure to show all those skills. If the job is clearly more specialized or a leadership position, then make sure that what you focus on in your resume sends a message that you are well-versed in that particular specialization.

Portfolio/Website Development and Resources

An *online website*, *portfolio*, or just *professional online presence* is necessary for just about every freelancer today. The first thing a person is going to want to see when considering hiring you for a design job is your work, and it is most convenient for them if they can click on your web link. Adobe has a portfolio builder that is pretty user-friendly and if you are in school, you may be able use Adobe for free. Other sites like Wix and Wordpress are popular. Even if it isn't a design job, a presence online will help potential employers get to know you, so even a profile on professionally oriented sites like LinkedIn is a good idea. Whatever sites you use, think about your online presence and what it might tell someone who does a web search for your name. Get some feedback from people who don't know you well.

This last Pro-perspective is from someone who has done it all. Her perspective inspires me because she shifted directions many times and every change had value and meaning. After you read her perspective, be sure to check out her website to consider how it reveals her unique story.

Pro-perspective: Dawn Hollingsworth, CLD, FIALD, WELL AP, A Dynamic Career

The journey of my career has not been a direct flight. In fact, there were many layovers along the way at points I would never have been able to forecast when I set out after college. My undergraduate experience taught me many skills, but nothing about how to get a job and what to do with a

degree in technical theatre. The first thing I knew was that I did not want to live in New York. That affirmation alone meant my career opportunities would be limited. Maybe because I wasn't urban enough for New York, but I found the Chicago theatre scene to be exactly what I needed to hone my craft.

In school I had thought of myself as a scenic designer, but in Chicago I had more chances to design lighting than scenery and it also afforded the ability to have a day job to pay the bills. The day job offered me experience designing industrial shows for corporate clients and some amazing travel. Those years were not easy but were priceless, being able to work with some amazing actors and other designers. It also taught me that learning a diversity of skills was the best way to ensure I would not starve.

Then a regional manager for a manufacturer approached me after seeing one of my shows and offered me a sales job. I had never thought of myself as a salesperson but he said I could make money so that sounded good. The decision to jump on board was predicated on the introduction of the first computerized lighting console and I knew unless I could get exposure to new technology, my skills would be left behind. I was still able to design plays, dance, musicals, and opera. After several Chicago winters, I moved to Los Angeles, where the opportunity to make a living in theatre was nonexistent. There were plenty of theatres if you liked working for free.

Eventually, I landed another sales position at a manufacturer, but this time I was introduced to the world of architectural lighting. This was a whole new environment of sales, finance, marketing, product design and engineering. My lighting background came in handy and I was able to go back to school for an MBA. I learned a whole new set of skills and designed my last show during those years. As luck would have it, I actually made it to Broadway with the Easter show at Radio City. After nine years and four promotions, the manufacturing operation moved and I chose to stay, so we parted ways. Honestly, I missed the collaboration of a design team.

I joined a design partnership without regret for leaving the security of corporate life. Everything I learned along the way prepared me for the next stop and looking back I had many rich experiences. Anyone who has worked for me knows I ask the interview question, "If you were a car, what kind of car are you?" The question isn't about cars; it is a calculated question to understand how much a person knows about their true self. Being honest with yourself and knowing who you are is more relevant than what you know.

In life not every decision works the way it was supposed to, but those moments teach you what you don't want, which is equally important. Some might think success is measured in the number of accolades or awards, but I believe it is in being fully committed to what you are doing in the present. If you can't commit, it is time to book a new destination.

Appendix 4

Suggestions for Scaling This Book

The content of this book draws the most effective aspects of two semesters of lighting courses as I used to teach them at the University of Arizona, plus content from our Introduction to Entertainment Design course. The students in the lighting courses are primarily made up of BFA theatre design and technology majors across all emphases (lighting, but also scenery, costumes, technical direction, stage managers, and sound), usually with a small number of majors from other disciplines including performance, film, television, and theatre arts. There are a number of considerations for how you might select or re-order the content for your particular situation.

For Educators Teaching. . .

Majors in Professional Training Programs

The modern necessity of teaching as many students as possible at one time makes teaching anything challenging. In my courses I typically have two to four lighting majors and 12 to 20 majors from other theatre and entertainment emphases along with a couple of students with little lighting background at all. Demanding as it can be to make sure that the lighting majors are challenged and the ones with no experience aren't left behind, I like it that way. I find that the diversity of perspectives has a huge impact on student learning and satisfaction. Students move on with better collaborative skills and a better understanding of

the connectedness of their work. If you are in that situation, this book should help. The most effective teaching will happen if you can tailor content dynamically, but the real value of this book is the meta-perspective it cultivates.

If you are teaching two semesters in a professional training program, that is to say with majors who will be doing this for a living, you should be able to go through the whole book comfortably, with companion lab and crew work, some of which can be drawn from the Appendices. If the students have to hang a show quickly at the start of the semester, you will want to address that right away in lab, possibly using the "How do I. . ." appendix, and you may want to move up a preliminary look at Chapter 4's Safety section. I didn't arrange the book like that because, pedagogically speaking, young students (especially if they did lighting in high school) are quick to get the wrong idea of lighting as technology rather than art. The more you can put the art and design up front, the better you will serve them. Just be sure to balance it with preparing them for whatever practical work they have to do.

Theatre and Entertainment Majors Not Focused on Lighting

If you are teaching students who won't be lighting designers but may work in theatre or entertainment fields, they need to have an understanding of how light is used and what lighting teams do. For them, you can comfortably navigate most of this book in one semester, possibly leaving out the highly technical sections, offering them only as further reading. Much of Chapters 4 and 5 can be skipped over or just referenced, particularly the sections on power, entertainment control, and laying out the light plot. Be sure not to accidently cue them that these topics are "too difficult" or "uninteresting". I've had students from other majors end up as successful technical specialists after getting their first exposure to it in one of my classes. Be sure to invite them to explore those topics so they can head in a direction that resonates with them.

Other-than-Theatre Majors

Though the content is designed as a deliberate journey from start to finish, most of it can be extracted independently for the particular situation you are in. Chapters 1, 2, and most of 3 will give a student of any art form a new perspective. Most of the projects can be done with any population as a fresh kind of creative exercise. The Pro-Perspectives can open any student's eyes to career possibilities.

High School or Vocational Students

Though the book has its best fit with college students, the language is intentionally accessible for younger students as well. The past decade has brought a shocking number of post-secondary Theatre Education degree programs to a close, leaving high school theatre teachers less prepared for the challenge, particularly in terms of technical training. I think this book can help and I encourage high school theatre teachers to cherry pick the content to serve their objectives. I recommend prioritizing the safety section and the Appendices if students will be doing practical work, and the practices around better observation and collaboration. Try to at least introduce the rest because you might be opening a door to their dream career they didn't know was there.

If You're Learning on the Job

This book will work well for you if you found your way into the lighting industry without higher education training. It will broaden your understanding of why things are done the way they are, what other job prospects might be available to you, and where you might go for further training. If you take up a Quietive Practice for yourself or even just begin to apply a reflective perspective as I frequently prompt the reader to do, you will likely find a deeper satisfaction in your life's work, regardless of which direction it takes.

Just Curious

If you're "just curious" about lighting, welcome! Take what you want, let it lead you in directions that resonate, and enjoy. Let your journey deepen your experience as a participant in arts and life, and share the awesomeness!

Glossary

This Glossary is limited to terms that are referenced in the text, but not specifically explained. Please find additional terms in the Index.

Atmospheric enhancement when particulate (like fog, haze, or water) is added to the air in a venue, usually to reveal beams of light

Chaser refers to scenic piece with light bulbs on alternating circuits that can create an effect

Contacts components inside an electrical device that conduct electricity

Field of view in this context, whatever the viewer can see while experiencing a creative work

Flat a scenic item that can look like a wall or structure

Front of house or FOH refers to the area before the stage in a theatre venue

Gel industry vernacular for the color filters that can be put in lighting instruments (the first ones were made of gelatin)

Gobos, templates, cookies thin pieces of metal cut to a specific pattern or printed glass that can be placed into a lighting instrument in order to project that pattern; film and television also calls them cookies, but cookies can also refer to anything put in front of a light to produce a shadow

Patch panel	in entertainment venues that have more circuits than dimmers, a patch panel is used to connect different circuits to dimmers at different times through the performance
Hazers, foggers, rain curtains	atmospheric effect devices
High key and low key	film-specific terms that refer to bright (mostly white) and dark (mostly black) lighting states
Key and fill	when two lights are used at noticeably different levels to create highlight and filled shadow
Lamp	the light source component in an entertainment instrument or fixture
Lighting Programmer	a technician whose job it is to program the lighting console
Load	a device or component that uses power in an electrical circuit
Magic sheet	a paperwork tool for quick recall of channels and other lighting console reference numbers specific to a given show
Memory control board	what the first computerized control consoles were called (this differentiated them from manual boards, which had no memory)
Pin-splitter	a tool used to maintain the proper space in the pin of a stage pin connector
Pit	the lower area in front of a stage where an orchestra might be placed for a production with live music
Proscenium	the frame around a stage in traditional theatres
Pull-down	a term used to describe a cue that dims (pulls down) the light in the area around a subject being highlighted in order to draw greater focus to that subject
Repertory	In this context, repertory refers to a situation in which multiple shows or pieces take place under one light plot
Special	a term referring to a light that has a specific singular purpose in a show (as opposed to lights that are part of a larger system of light)
Value	an art term referring to the brightness of a color
Wash	a term referring to lights focused over a large area
Wings	the sides of the stage in a traditional theatre
Work light	lights that are hung in order for visibility when the show-specific lighting is off

Index

Note: Page numbers in *italic* refer to Figures